D0477270

Color and the Structural Sense

Color and

the Structural Sense

WILLIAM CHARLES LIBBY
Carnegie-Mellon University

Prentice-Hall, Inc., Englewood Cliffs, New Jersey

Library of Congress Cataloging in Publication Data

LIBBY, WILLIAM CHARLES.
 Color and the structural sense.

1. Color. 1. Title.
ND1488.L52 701'.8 73-20370
ISBN 0-13-151316-8

COLOR AND THE STRUCTURAL SENSE
William Charles Libby

© 1974 by PRENTICE-HALL, INC., *Englewood Cliffs, N.J.*

10 9 8 7 6 5 4 3 2

Printed in the United States of America

PRENTICE-HALL INTERNATIONAL, INC., *London*
PRENTICE-HALL OF AUSTRALIA, PTY. LTD., *Sydney*
PRENTICE-HALL OF CANADA, LTD., *Toronto*
PRENTICE-HALL OF INDIA PRIVATE LIMITED, *New Delhi*
PRENTICE-HALL OF JAPAN, INC., *Tokyo*

FOREWORD

Rarely does a book devoted to a technical subject call forth the responses appropriate to art or poetry. Libby's discussion of color possesses this unusual capacity, not only because of the author's felicitous style, but because he loves the subject and knows how to talk about it. Color itself is a matter of passionate concern to artists, yet its study has often been regarded as a necessary nuisance. Quite possibly the problem has lain, not in the specialized character of the material, but in the fact that few writers possess the artistic experience and teaching skill needed to carry the *information* about color from the realm of technology into the world of clear idea and expressed feeling. After all, color has as much to do with human behavior as it does with the physics of light, optics, and the chemistry of paints and dyes.

Furthermore, it involves that most remarkable and intimate of human organs, the eye. Physiologists know a great deal about the eye; psychologists know much about vision; still neither seems to know what the artist has learned—through intuition or through those marvelous researches that take place in the laboratory between the eye and the brain.

The great practitioners of color as an art have rarely been able (or willing) to convey their enthusiasm about the subject in writing. So we are happily obliged to examine their work directly. But delightful and rewarding as it is to drink in the color of a Rubens, a Turner, a Bonnard, or a Rothko, the serious artist or student of art wants something more: he wants to know the aesthetic as well as the chemical and physiological causes of color effect in his experience; he wants a clear exposition of the coloristic tools available to him; and he wants an explanation of the role color plays in the experience of viewers. These questions are admirably (I am tempted to say "painlessly") answered by Professor Libby.

A major virtue of the present text lies in the refusal of the author to write as if he utters the last word on the subject. Too experienced as teacher and artist to believe that any book can replace the excitement of personal encounters with the phenomenon itself, he instructs gently but firmly—so as to challenge, provoke, and stimulate, but not to overwhelm. As a result, the reader will find here a reassuring sense of expertise and conviction, but he will not feel denied the right to disagree, to conduct his own inquiries, to learn from others, and to compare what he has discovered with the ideas introduced by the author.

Reading, of course, is a type of seeing. But it is at once somewhat more and a great deal less than *seeing color*. So Professor Libby has wisely decided to write about the dimensions of color which can be honestly taught and intelligently understood. Still, if he discusses the subject in rational language, his observations flow from the experience of one who also sees with the inner eye. A long and productive career as painter and printmaker stands behind these pages. You will sense this (you may "see" a bit) as you read. I believe students, artists, and laymen who read Libby's discussion of color will find themselves quietly enlightened and gently persuaded. They will be truly taught.

Edmund Burke Feldman

ABOUT THE ILLUSTRATIONS

One of the more mischievous "truths" is the ancient belief that a picture is worth a thousand words. For it is more probable that a picture of merit is worth not a single word, and that the usual practice of providing visual illustrations for what can as well be described in words, is wholly misguided. Certainly there exists, quite apart from word symbols, a visual language which is broadly based and capable in its own way of expressing feelings as well as ideas. To put it plainly, there exists a language which does not depend on verbal intelligence and which is in all respects as communicative and eloquent.

There is wide agreement among artists that to describe a painting by Rembrandt or to paint a sonnet by Shakespeare is simply to

invite frustration. They think that both are exercises in irrelevance, since in their inspired forms, verbal and visual statements are not equatable and not interchangeable. They are undoubtedly right. But language is much more than a poetic means. It is the means by which men shape and exchange a variety of ideas in a variety of ways, and there is no reason to assume that at *any* level of communication a picture, or visual symbol, is merely a convenient and efficient substitute for words. This assumption persists, however, because visual symbols touch the mind by direct and sensuous routes, and with an exceptional kind of immediacy. But even so, it is no justification of the popular view that visual symbols should be instantly and completely understandable if they are good. The opposite view may, in fact, be more correct.

Therefore, the illustrations presented in this book are not simple translations of what has been written, but are visual conceptions of some of its central thoughts. Nor will the sense of these conceptions be at once apparent, since the illustrations are abstract and require a special kind of "reading." For this reason, some commentary has been provided which will make the transition from words to visual symbols less abrupt and uncertain. Once this purpose is accomplished, of course, one hopes that the reader (and viewer) will discover aesthetic merit as well as meaning in the visual symbols themselves.

Acknowledgments

Books cannot be said to originate, but to gestate. This one is no exception, since it reflects my long-standing addiction to some of the theoretical and practical problems of color in art and in the world at large. This addiction began under the amiable prodding of the late Wilfred Readio of Carnegie-Mellon University, whose influence as a teacher was as irresistible as it was disarming. It has been nourished over the years by conversations with friends and colleagues, and by a rapidly growing conviction that the present state of our knowledge about color and its relation to the arts is unnecessarily and deplorably meager. This book is a product of that conviction and of a concern shared with many.

As every thoughtful person knows, the preparation of even the simplest manuscript requires enlightened assistance and counsel.

In this connection I want to express my appreciation to Orville M. Winsand, Professor of Painting and Sculpture at Carnegie-Mellon University, whose perceptive suggestions were always available, and to Robert H. Gibson, then Professor of Psychology at the University of Pittsburgh, who graciously reviewed the text in order to protect me—and indirectly, you—from gross errors in the treatment of technical material on color vision and perception. The contributions of Edmund B. Feldman, Professor of Art at the University of Georgia, were inestimable.

Contents

ONE: NAMING COLORS

1

TWO: COLOR CONTRAST 63

THREE: THE STRUCTURAL SENSE 93

Naming Colors

CHAPTER ONE

To pursue an interdisciplinary subject is to pursue an echo, since in either case one must be reconciled to endless pursuit and uncertain victory. And color is clearly an interdisciplinary subject lying at the junction, as it were, of such fields of specialized interest as physics, chemistry, physiology, psychology, and art. With one conspicuous exception these are fields of scientific inquiry. This is not to say that the serious aims of science are those of art, for their ultimate purposes could not be more different. It does suggest, nevertheless, that an inclusive study of color, whatever its origin, should in time gravitate to the point at which these sciences and art can interact and, making common cause, add uniquely to our understanding.

**Color
and the
Human Spirit**

Many will say that art cannot instruct science; and if we are speaking of the quantitative aspects of color, they are right. However, it is art which brings to the study of color the fascinating human dimension which distinguishes sensation from quantitative matter, and it is that dimension, always synthesized in art, which gives color its meaning. For if the physicist asks what color is and how it behaves, the physiologist asks how it is sensed, and the psychologist asks how it is perceived and influences human behavior, it is the artist who asks, in contrast "What can color do for the human spirit?" It is apparent, too, that if the artist is to answer his own question eloquently he will have to assimilate information about color as it collects on every front.

To be sure, no one knows how much of this information is or will be relevant to performance in art. But whatever one's bias, it is surely senseless and futile to resist the acquisition of knowledge or to attempt to suppress it. We all learn continuously and are necessarily changed. And since, in this respect at least, artists are not different from others, the art of the past is as much an annotation and revelation of general history as it is a succession of styles, schools, and movements in art, each evolving as a dependent of its predecessor. It is after all for this reason that art is traditionally accepted as a reliable index of the character, aspirations, and mood of the society which produced it. If, then, contemporary art is especially revealing, it must be because so much information relating to present-day society is accessible to so many who can examine and understand it, including artists.

**Art as a
Reflection of
Cultural Interest**

While it cannot be said that artists react more quickly than others to events and new modes of thought, it can be said that they react. In retrospect, it is fairly clear that Cubism was more a response to an expanding scientific and intellectual interest in the structure of matter than it was a rebellious assault upon tradition and therefore upon the sovereignty of "the volume" in art. Similarly, Abstract Expressionism was more a response to the exciting reformulation in this century of the nature of reality than it was an impatient rejection of observed subject matter in painting. And certainly the current interest of artists in color has been stirred by cultural soundings, for it is as much a response to our accelerating awareness of the mechanisms of sensation, perception, and illusion as it is another attempt like that of the Fauves, to free color of its naturalistic constraints. Artists have

2

for some time accepted the notion, so dramatically advanced by the Fauves, that specific colors are not inherent and constant in things—that roses are red, *maybe*. They are now inclined to view color as an additive experience consisting of a series of describable psycho-physical events. Like all additive experiences, it is greater than the sum of its events, and in this case, quite different from them.

Color as a Series of Events

From this point of view, color is not a simple perception. It lives in the events of the visual process itself, and is a prelude to perception as well as one of its consequences. Originating as electromagnetic energy, it moves through space as waves and is admitted to the inner eye; it is converted there into electrochemical energy by receptors in the retina, and discharged then into the optic nerve and visual pathway as encoded impulses; finally, it is perceived and evaluated in visual centers in the brain, where neural impulses are somehow reconstituted. Color is thus related to these events as smoke is to fire. But often even though one can see and smell the smoke it is difficult to find the fire. How, then, can the causes of the color experience be found? Since it is in the eye that lightwaves are collected, scanned, and converted into impulses which will be appreciated as color, the search might well begin there. Should this be successful, however, the desire to understand fully would soon force us to examine the physical characteristics of light, on the one hand, and the subjective characteristics of perceptual and symbolic responses, on the other. It would force us, in other words, to recognize that color is experienced as a series of dependent events, not insulated ones.

Vision and Motivation

This view of color as a series of interacting physical, physiological, psychological, and psychic events is more than academic, for although the primary role of color in works of art is undeniably expressive and aesthetic, the artist's initial interest in color frequently is not. Perhaps it was impatience with an inflexible aesthetic tradition which triggered Impressionism, but it was knowledge of the physical aspects of color which provided its heroics. And in more recent times, in optical art and in art which is luminal, artists have once more found in the events of color vision a reason and a means to produce a novel art. Optical art, for instance, is relentlessly subjective, not only because it creates spatial contradictions but because it places the mechanism of color vision under varying degrees of stress. It does this most

3

often by exploiting the natural antagonism between complementary colors, for the complement of a warm color is in nearly every instance a cool one. And since the compound lens of the eye accommodates to warm and cool colors as to near and distant objects, it cannot adjust simultaneously to both. Nevertheless, the lens attempts involuntarily to adjust, and the tension which this induces, first in the musculature of the lens and then in the mind, is considerable. In extreme cases, it is intolerable.

Op Art
and
Participation

Still, it would be a mistake to dismiss optical art as deception, for the line between illusion and reality is thin. Nor should we assume that stress is necessarily undesirable, since it can frequently be equated with "attention." We should recognize, instead, that the special significance of optical art lies in the way in which it makes us fitfully aware of the part which we play in the realization of the work, for it is precisely because optical art cannot be viewed disinterestedly that it challenges the long-cherished assumption that the work of art is distant, constant, and self-contained. We should realize, too, that whatever the ultimate importance of this type of art, its characteristic visual devices have their origin in experiments in physiology and psychology.

New Insights

It is increasingly clear that artists are staking out yet another approach to illumination and color, for they have begun seriously to thrust light itself into works of art. This is not an improbable thing to do, since the physical composition of light is determined by the nature of its source and by the interference which it encounters en route to the point of sight. The most common types of interference are, of course, natural surfaces and pigments, which we know reflect light selectively. But such media of interference as translucent films, vapors, and prisms also act upon light in understandable and predictable ways, and their appearance in works of art is surely significant. And so while those who are unwilling to accept a fluorescent fixture as a work of art may be wholly justified, they should be reminded that we live in a world which is gradually and irreversibly asserting its independence of the sun. At this moment in history, a work of art can be created, exhibited, criticized, sold, and enshrined in a museum without having been seen in daylight.

It is inevitable, certainly, that as the sun is more often replaced and our environment changed, more works of art will be

produced which are luminal as well as illuminated. For in contrast to the works of Impressionism, which represented an imaginative reconciliation of physical theory and color in painting, these contemporary works are symbols of an emerging urban environment, and perhaps of a vanishing night. Surely they are also symptoms of the artist's restive spirit, for the luminal approach to color is quite unlike that of Abstract Expressionism, which seeks to stir responses at obscure subconscious levels, and different from that of optical art, which aggressively throws perceptual systems out of rhythm. This diversity suggests that, in practice, color serves highly specialized purposes, and that an in-depth study of color would no doubt concern itself with the philosophies and effects peculiar to all of them. Still, a study which is less ambitious can be extremely useful.

Why a Study? Such a study can be useful if it broadens the usual definition of color, so that "color" is not an attribute of surfaces and things but the sum of a series of natural and psychological events. It can be more useful if it describes the rationale on which color relationships are based and suggests ways in which this rationale can help us to think about color structurally. It can be most useful, however, if it argues successfully that the imaginative use of color depends as much upon an understanding of its causes as upon a vague appreciation of its effects. Unfortunately, much of what we "know" about color is inherited lore, harmful because it seems so adequate. To know simply that red, yellow, and blue are somehow *primary*, that certain colors, called *complementary*, are opposite in hue, and that some colors appear to advance as others recede, is to know little that is of theoretical or practical value. Curiously, the evidence which supports these assumptions will not be found in art. Nor is it probable that evidence for new assumptions about color will be found there, for it will lie, as in the past, at the confluence of science and art.

The Need for a Color-Naming System

Despite its eventual complexity, the study of color should begin simply. But it is surprisingly difficult to discuss color, and especially to discuss its role in works of art unless for every color there is a unique and acceptable name. Finding such names should be easy; and if by every color we mean the few elemental colors of the visible spectrum—red, orange, yellow, green, blue,

5

and indigo—it is. But as a practical matter, the artist works with color which is produced by light reflected selectively from surfaces, and it has been estimated that at least 30 thousand different colored surfaces are created in this way. How, one wonders, can even these thousands of surfaces be uniquely named, when neither the popular practice of assigning sentimental and often exotic names, nor the professional one of substituting the names of pigments, provides real distinctions.

First, we should remind ourselves that it is by naming that we describe, classify, and distinguish among things. Moreover, all names do not achieve the same degree of clarity, for a name which is disastrously inadequate for one purpose may be apt, or even eloquent, for another. What a simple man picturesquely calls a "doctor-bird," and a casual bird-watcher calls a "hummingbird," an ornithologist will call an "archilocus." These names suggest varying types and levels of interest, and are not sensibly interchangeable. The same is true in the naming of colors. For while it is not a mistake to name a color Contemplation, Prussian Blue, Chinese Vermilion, or Lucretia, it is surely a delusion to suppose that such names are more than romantic and elusive labels, subject to change without notice. Inconstant as well as unclear, they are time-honored barriers to communication and to even the simplest understanding of color in the arts.

Even so, merely to name colors uniquely will not completely meet the needs of reason and of art. They must, in addition, be named systematically, so that when two or more colors are brought together we can perceive in a moment the ways in which they are different or alike, and in general, to what degree. Artists have no doubt been aware for centuries of the practical and aesthetic need for such a system, and have surely evolved personal and intuitive models of it. However, it was for Albert Munsell, an artist with a bent for science and an extraordinary interest in color organization, to tell artists and others how a system of this kind might look and work. He did this in 1905, with the publication of an ingenious and now well-known system of color notation.

The Work of Albert Munsell

As a working artist, Munsell knew the work of art as a package of subjective relations. He must have known, too, that it was

pointless to speak of color relationships if color elements could not be isolated, described, and named. His purpose, he said, was to devise a method of naming colors which would be analogous to the system of notation so long and so effectively used in music. That he would not succeed was predictable, for while this analogy is alluring, it is far from perfect. It is true that sounds vary in pitch, intensity, and duration, and that colors too vary in three distinct and different ways. And it is true that, like sounds, colors vary independently in each of these three ways. Here, however, the parallel ends. For individual sounds can always be identified when several are sounded simultaneously, as in a chord, while individual colors frequently leave no traces of themselves when they are fused. White light, for instance, can be produced by combining innumerable pairs of complementary colors, with the result that we never can be certain of the way in which this sensation has been put together. Every color-naming system will suffer from this defect. But a system which does not do the impossible may nevertheless have great merit, and the system proposed by Munsell is widely respected by those who are acquainted with its language and its form.

The Munsell System

Munsell saw each color as a three-dimensional construct, and concluded that for this reason each could be placed in a geometric form so that it occupied an exclusive position. This concept was not entirely new, to be sure. Von Bezold, demonstrator of the Bezold effect, and the famous theorist von Helmholtz had described color solids, as had others. As recently as 1879, the physicist Ogden Rood had declared that all colors could be named and related if they occupied theoretical positions in a solid which joined two identical cones at their bases. The tip of the upright cone would be white, and that of the inverted one, black. He then envisioned a continuous band of hues, in the order of the spectrum, uniting the cones at their bases, and parallel bands of color, successively lighter in one direction and darker in the other, making a transition to their tips. In his solid, each hue would become gray as its position became more central. While this form expressed three-dimensional variation, it was oversimplified in the manner of those which preceded it. We must infer from it that the most vivid hues in the spectrum are median between black and white, and this is clearly not the case. Perhaps it was in response to such convenient symmetry that Munsell felt impelled to devise an alternate system which acknowledged the fact that in the visible spectrum the most intense yellow hue is extremely light while the most intense indigo (or purple) is dark.

7

The form which naturally emerged, then, was highly irregular, and if we look closely at the ways in which colors change, we can see that this was inevitable.

The Dimensions of Color

Three Variables It is inescapably clear that colors vary in three ways, that these variables are dynamically balanced in every color, and that when this balance is readjusted a new color is created. The artist reacts to these adjustments out of professional necessity, and is more aware than others, perhaps, of their kaleidoscopic effect upon everything we see. For him, the visual world exists in full color and on a wide screen; for while he knows that colors can be red or green, light or dark, and intense or not, he also knows from experience that they are forever in a state of suspended and promised change. In pigment mixtures, for instance, this promise is always fulfilled, for then colors may change continuously and, to the complete consternation of the unwary, in three ways at once. For this reason matching colors can at times be vexing as well as perplexing, and much like predicting the lurching thrusts of a bat on the wing. Even so, the difficulty which one encounters in mixing pigments is as ancient as the practice itself, and it was not for Munsell to announce belatedly that every color is indeed the sum of three dynamic variables. His purpose was to describe and represent these variables graphically and to relate them precisely. In doing so he found, as others had, that every color can be described as a unique combination of these universal variables, much as the shape and size of a rectilinear volume can be described by its dimensions. Because of this similarity, he decided that the variables present in every color are in every sense its dimensions. He decided, further, that they should be named *hue*, *value*, and *chroma* (see Plate 1). The names which Munsell gave to his dimensions of color are not in themselves important. Scientists in speaking of the same qualities use different names, and many artists prefer names which they feel are more appropriate because they are more expressive. A scientist who speaks of the brightness of a color is referring to its value, and one who speaks of its saturation, as artists do also, is referring to its chroma. But whatever one's semantic preferences, it seems desirable to name colors in the regular sequence—hue, value, and chroma—for this is evidently the order in which these qualities, or dimensions, are perceived and appreciated. The earliest color

8

discrimination among children is no doubt that of hue, while subtle differences of chroma are the last to be recognized even among those who are experienced in the arts. If we are to begin at the beginning, then, we should define this primary quality before moving on to a consideration of the others.

The Color Dimension: Hue

Hue and Color

The words *hue* and *color* are used interchangeably in nearly all conversation and in much of the literature on color. This is understandable since dictionaries do not distinguish clearly between them, either. It is even conceivable that this traditional confusion caused Munsell to give the name *hue* to the first of his color dimensions, for by doing so, he declared that hue is not merely color but one of the universal variables present in all colors. Specifically, he said that it is the variable which tells us to which class of color a particular one belongs. Such classes of color are red, yellow, green, blue, and violet. To these may be added hybrid classes such as yellow-red, yellow-green, blue-green, blue-violet, and red-violet. This kind of interpolation, unlike the quality of mercy, can of course be strained, as when a hue is named yellow, yellow-red. But it need not be, since broadly representative classes of color are sufficient for all artistic purposes. By arranging these representative hues in an ordered, circular sequence, we can make the relationships among them unusually visual; and having arranged them we will find that we have also reproduced what is now a familiar and classic form, the color circle. Yet the color circle is a trivial gimmick if one has no elementary knowledge of the visible spectrum and of the natural way in which this circular form evolved from it.

Natural Light

White light, or sunlight, is oddly invisible. We see it at its source, the sun, and when it is reflected from surfaces around us. We cannot, however, see it while it is en route, and if at a given moment every object in the atmosphere and on the earth absorbed the sunlight which reached it, we would find ourselves in absolute darkness and able to see only the sun itself. We see sunlight, when we do, because it has been reflected, dispersed, or otherwise scattered. These deflecting surfaces may be minute, like the dust particles and drops of moisture which produce color in the atmosphere, but however sunlight is deflected, we see it because we perceive its color. Certainly the surfaces which turn

back light are not themselves colored, for if they were, the startling color alterations which we know can be produced by changes in illumination would not be possible. If a surface is red, it should not be possible to make it purple merely by changing the character of the light which it reflects. Since this can be done easily, it is apparent that we do not see surfaces because light reveals their color, but because these surfaces reveal the color which is in light.

The Visible Spectrum

Some three hundred years ago, in a historic experiment, Isaac Newton found "the color" in light. In a moment of insight or of chance, Newton directed a beam of sunlight into a glass prism. Glass is a denser medium than air, and so the light was refracted, or bent, as it passed through. This he expected. But the light also dispersed systematically, its short waves refracting more and its long waves less, and on leaving the prism, was multicolored. This he did not expect. Moreover, its colors arranged themselves as in a rainbow, with red, orange, yellow, green, blue, and indigo appearing in a continuous series. He concluded that the refracted beam of light varied in color as its wave components varied in length, and that the net effect of this was to order the light in an ascending, or descending, sequence of wavelengths and colors. Of two things we may be assured. First, that balanced natural light, which is sunlight, is divisible into at least six easily perceived hues; and secondly, that there is a reliable correspondence between these six hues and the lengths of the lightwaves which evoke them.

Light is Visible Radiation

Having separated sunlight into its color components, Newton promptly recombined them by using a second prism which reversed the action of the first. The colors which he separated and then fused into sunlight once again are the visible spectrum. So we should remember that "light" is simply the name given to a small segment of an extensive electromagnetic spectrum which includes infrared, ultraviolet, cosmic rays, and more. Virtually all of the electromagnetic spectrum is energy generated by the sun and radiated as waves of varying lengths; lightwaves are merely those few which, because of their lengths, are perceived as color. To speak of visible sunlight is to be redundant, since light is by definition that part of the sun's radiation which is visible.

10

From the artist's point of view, too, Newton's experiment was an exercise in discovery, for it revealed not only the colors which constitute sunlight but also some of the natural and inevitable relationships among them. It revealed, first of all, that there is in white light a constant order of hues. This order is dramatized when sunlight is directed into a prism as a strip of light, for then the light, having been refracted, reappears as a band of six transverse colors. These are, once again, the hues of the visible spectrum. Surprisingly, they are not uniformly represented, red and orange appearing as wide divisions of the band and yellow as a narrow one. Despite the clarity of its major subdivisions, the band appears to be continuous; but this is only because adjacent hues fuse to create subtle, intermediate ones. Yellow-green, in which yellow and green are discernible, is typical of these fusions. But the most significant and atypical fusion occurs when the terminal hues of the spectrum—purple-red and purple-blue—are joined to produce the sensation called purple. This hue does not exist in the natural spectrum, and the fact that it can be produced by fusion, as described, suggests that the ends of the spectral band be joined. The band would then be continuous. This can of course be done, in fact as well as in imagination, and when it has been done, the visible spectrum is a continuous band of colors looking for an expressive form.

Measuring Hue Contrast

Predictably, the most expressive form in this case is a polygon. This is so because the spectral band, pushed outward as if it were elastic, will naturally assume the shape of a hexagon with a major hue in each of its angles. As intermediate hues are added and the form adjusted accordingly, it will look increasingly circular. It is true that this figure will be an imperfect portrait of the visible spectrum, since it denies the uneven distribution of hues which is so apparent there. But it will have compensating features, for it will show hues in a fixed and natural order and have the additional virtue of measuring their contrast. As it turns out, in this figure, contrast of hue can reliably be equated with distance, for when the dominant hues of the spectrum, including purple, have been distributed equidistantly in a circular pattern, we will find that those of greatest contrast are in diametric positions. These are the hues called complementary. Thus yellow and blue-purple will lie on the same diameter, indicating that they are as different as possible from each other and more different from each other

11

than from any other hue. The nature of the contrast between complementary and diametrically related colors will be discussed in another context. It is mentioned here only to convince the skeptical that the circular pattern on which Munsell and others have built their systems is not a whimsical accident of history.

The Color Dimension: Value

Higher and Lower Values

Hue is the distinction, then, between contrasting classes of color such as red, yellow-red, and yellow. This means that while red can become yellow-red (orange) through the admixture of yellow, it cannot *be* yellow-red, and certainly cannot be yellow. Value, on the other hand, is the distinction between any color and a lighter or darker one. But every color, irrespective of its hue, can become darker or lighter as on a sliding scale, so that in value, all colors are potentially the same and potentially different. This extreme adjustability makes value contrast unlike that of hue, for it means that while red cannot be yellow, as a swan cannot be a sparrow, it can be of the value of yellow or of any other hue. More often than not, though, we are concerned in art with the contrast between colors which are different in value, and in these instances the value of the lighter one is said to be higher and that of the darker one, lower. While this terminology completely ignores our understanding, which tells us that lighter colors in fact reflect more light, it recognizes the experience of our senses, which tells us that natural light increases as the sun ascends. As a practical matter, it is not at all difficult to determine which of two colors is of higher value, particularly when they are adjacent. Such random, relative distinctions are too inexact to be useful, however. After all, the color of higher value may itself be either light or dark, as indeed both colors may be. And so, how high, one wonders, is high?

One-Dimensional Colors: White, Gray, and Black

The answer is that it is as high as white; for the value of any color is the degree in which it resembles terminal values, and these are black and white. But black and white are themselves colors, and we find ourselves hung on a contradiction. Obviously, since no color of the spectrum can be black or white, every color cannot be potentially of the value of every other. This contradiction can be resolved if, by an act of intellectual gymnastics, we accept the notion that all colors are not three-dimensional constructs. The exceptional colors, which will be one-dimensional and hueless,

will be black, white, and an undetermined number of those called gray. The last are apparent mixtures of black and white, distinguishable from white because they are darker, from black because they are lighter, and from each other for either reason. Inasmuch as these colors are dimensional only in value, they are the ideal elements of a value scale. With such a scale one hopes of course to determine the value of any color by visual analogy, or direct visual comparison, and that hope can be realized only if the scale contains enough gradations to express the great contrast between black and white and yet not so many that the difference between any two values is indecisive.

Measuring Value Contrast

A scale which attempted to represent all just-perceivable values would be astonishingly extensive. It seems that in a band of continuously blended grays from black to white, a person of extreme visual acuity can perceive as many as 150 changes, and that in nature, where the amount of light is considerably greater than elsewhere, this number can be counted in the thousands. Even if we could produce such a demanding value scale we would not, for as no useful purpose is served by placing every discernible hue in a hue circle, none is served by a too-finely graded value scale. And yet, if 150 graded values are far too many, what is the optimum number? One can only make an educated guess, since these gradations are determined by consensus.

Life would be simpler for artists and others if a value scale could be produced by adding regular increments of white to black, and vice versa. Unfortunately, equal amounts of black and white, whether in mixtures of pigment or of light, will not produce a gray which appears to split the difference between them. The gray which does, when light is mixed, is one which reflects only about eighteen percent of white light. This means, perhaps, that in the middle and lower value ranges, where the amount of light required to produce a just-perceivable difference is relatively small, we perceive fewer value changes but perceive them more quickly and with greater certainty. In this connection, the behavior of pigments is interesting. Artists know that pigments mix erratically, and that the amount of light color required to raise the value of a dark color only slightly is negligible when compared to the amount required to make a corresponding change in a much lighter one. Few practical experiences are more chastening to an artist than the one in which he mixes down to a new color, overshoots its value, and then tries in the same mixture

13

to recover. The addition of an awesome amount of light pigment always produces an unimpressive change in the value of the pigment and an impressive change in the artist. This experience has been explained, though surely not eliminated, by physicists Weber and Fechner, who have demonstrated that the amount of light required to produce uniform value gradations increases geometrically, not arithmetically, from black to white. In doing so, they have also given us the means to reproduce an acceptable value scale. However, formulas simply conform to phenomena, or try to, and the judgments on which this formula depends were first reached by observation and consensus. The gradations in the value scale of Albert Munsell, for instance, are the averaged responses of seven competent observers. The decision to rest his case on the testimony of seven witnesses is unimportant, for his economical scale of eleven values, including black and white, has proved to be entirely adequate in the arts.

The Munsell Value Scale

These gradations are crisp. Black, which is the absence of light, or if we are dealing with surfaces, its complete absorption, is appropriately named zero. As the values rise rhythmically, their numerical ratings increase also, so that white, which is daylight or its equivalent, is named 10. By equating any color with the gradations of this scale, we can determine its value and give it a name. This accomplished, the scale has served its purpose. Nevertheless, it has another and perhaps even more important virtue. The unvarying sequence in which hues appear in the spectrum has been mentioned. But colors also appear there in a descending order of values, for it is apparent that yellow is the lightest of all hues and indigo, or blue-violet, the darkest, and that other hues lie between them at graded value levels. This is a natural order of some significance, and the vertical scale of Munsell, with white above, as a glowing luminary, and gradually diminishing grays below, reaching to black, allows us to isolate and describe it.

Hueless Contrast

The very existence of colors which are one-dimensional underscores the distinction between the dimensions of value and of hue, and the temptation to ask which is more critical, in the visual world and in art, is difficult to resist. Both are essential to an understanding of color, and the question may be moot. It is unarguable, however, that if the observable world were suddenly hueless it would continue to be both intelligible and interesting, though probably less clear. Many kinds of animals function and

survive in a world which, for them, is hueless, and much of the visual information on which we depend for survival and aesthetic satisfaction is the same. For instance, most photography and much television, at least to the present, has been what is commonly called black and white. This has meant chronic frustration for those millions who are addicted to watching sports on television, for contestants are invariably identified by the contrasting colors of their uniforms, and when this contrast is one of hue, which it usually is, it is often indistinguishable in black, white, and degrees of gray. This frustration is understandable, since invisible differences of hue can only be meaningless, and it is eliminated at once in three-dimensional, or color, television.

Plainly, then, black and white television and photography demonstrate the urgeht need for decisive value contrast in visual perception. This need is certainly appreciated by the colorblind, who must live with hue deficiencies of various types and must in many cases make value distinctions or make none. It is clearly acknowledged, too, in the famous Ishihara tests for color deficiency, for they frankly assume a constant ability to recognize value differences when the ability to recognize and distinguish between hues is missing. Without this assumption these tests are pointless. All in all, it is possibly true that achromatic, or hueless vision is the elemental one from which our present color vision has evolved and is still evolving. If that is true, Western painting has lived through a similar evolution.

Chiaroscuro
Painting

It must be evident to every experienced artist that European painting, from the Italian Renaissance to Impressionism, had its ancestral lines in the great chiaroscuro tradition of Tintoretto and others. This is only to say that it was achromatic, or black, white, and gray in structure. The frescoes of the high Renaissance, for instance, with Michelangelo in the center ring, were wholly underpainted in tones of one color (values) and then glazed to introduce local color (hues). This procedure was in some measure dictated by the materials and techniques of fresco painting, and was entirely justified. In succeeding centuries, however, paintings were conceived and structured in the same spirit even though their technical requirements and purposes were quite different. In the present century, as artists have come to know the chromatic and dimensional nature of color, there has been a fortunate change. Vivid, subjective, and emotive hue relationships are now characteristic of all that is contemporary in the

visual arts. It is reasonable to think that this passionate concern with hue contrast is an attempt to compensate for centuries of indifference and neglect. Predictably, it has been followed by an equally vigorous interest in the dimension of color which Albert Munsell called chroma, but which most artists call intensity, or occasionally, saturation.

The Color Dimension: Intensity

Measuring Intensity

Intensity presumes the existence of hue, and is the distinction between any color and a more saturated or less saturated one. It is the dimension in which red, for instance, can be more vividly or less vividly red. Unlike hue and value, which can be visualized independently of each other, intensity cannot be visualized except as a variable in a scale in which a hue is systematically affected. This can be arranged, of course, since the colors white, black, and gray in addition to being hueless are without intensity; for by placing a gray at one end of a linear series and a fully saturated hue of the same value at the other, we can make a scale in which hue and value are constant while intensity is not. By letting the gray of this scale represent zero intensity, we can measure the gradually increasing intensity of the hue. When this kind of scale is painted in natural light, and one is produced for each spectral hue, we will find that each scale varies in length according to its hue. The red scale may consist of as many as fourteen easily differentiated gradations, and the green scale as few as eight. This reveals reflective deficiencies in the pigments now available, and is of little theoretical interest. But we will find, too, that each hue reaches its greatest intensity at its natural value level, and this is of some interest.

The Natural Order of Intensities

Tints and Shades

It is of interest because it adds a third order—intensity—to those of hue and value; and taken together, and interacting, these three orders constitute a natural system. Consider, first, that the values of the colors of the spectrum descend from yellow in two parallel sequences. One sequence is yellow, yellow-red, red, red-purple, purple, and blue-purple; the other is yellow, yellow-green, green, blue-green, blue, and again, blue-purple. If, then, every hue reaches its peak intensity at its natural value level, an intense

16

more intense than another, and that both are more intense than a third, is to imply the existence of a firm measure. This measure could be zero intensity, as it could be an average intensity for all hues or a concept of full intensity for each major hue. Whatever one's preference, it will be a quantitative unit to be memorized. And since the ability to differentiate among hues, values, and degrees of intensity must be learned in this way, describing and naming colors dimensionally appears on the face of it to be an imposing problem. But in practice it is not really difficult to memorize an abbreviated value scale, a ten-hued circle, and a pivotal intensity. Difficult or not, these skills are as indispensible to those who expect only to respond to color relationships as to those who expect to create them. They are indispensible because without them color interaction is blurred and nonreproducible. It is nonsense to suggest that a color-naming system can provide the sensitivity on which such skills depend, but there is little doubt that it will exercise and cultivate it.

Why a Color-Naming System? By fixing the dimensions of color and by offering a terminology for relating them which is both verbal and visual, a system for naming colors assists us directly in at least two ways. For in the process it gives us a means to think about color in a structured way. To some, for reasons which are neither clear nor persuasive, this is a mixed blessing, and so color systems are occasionally berated in the visual arts—especially in the teaching of these arts—as serious deterrents to intuitive and spontaneous expression. Employed as a means and a justification for aesthetic decisions, they probably arc. But there is no doubt at all that if we are to advance our understanding of color relationships we must isolate their elements and name them in terms which are vivid and widely accepted. To do less is to risk making great sounds without making great sense, and this risk is always present and evidently irresistible when the verbal and visual disciplines of a system are not. These disciplines insist that we define colors in the broadest sense, so that their individuality is distinct and their relation to other colors unequivocal. It follows, then, that if the criterion for naming individual colors distinctly is three-dimensional, the system which hopes to relate them will be most uncomplicated, and therefore most effective if it is an extension of these dimensions. Albert Munsell has proposed such a system. It establishes the position of each color spatially so that all colors, including those which now exist only theoretically, occupy exclusive positions in an imaginary form, or "solid."

yellow will necessarily be lighter than a yellow-red or yellow-green of the same intensity, and these in turn will be lighter than a red of matching intensity. These relationships imply that the intensity of any color is a function of its value. For when the value of yellow is lowered, its potential intensity diminishes, and will continue to diminish, until at the natural value level of blue-purple it is about zero. Conversely, when blue-purple has been raised in value to the natural level of yellow, it is almost without intensity. This functional relationship applies to all hues, and so "tints" and "shades" are not simply light and dark colors of diminished intensity, as many are inclined to believe, but colors which are appreciably lighter or darker than they would be at full intensity. For this reason, a tint of blue-purple may not be a light color at all, and a shade of yellow may in fact be a light color and at the same time be darker than a tint of blue-purple.

Happily, we can describe colors without using the words *tint* and *shade*, which only encourage us to think that we are naming colors when we are not. We are encouraged in this belief even though no one can predict precisely the value and intensity of a shade of yellow, for instance. Nevertheless, these words are indirectly useful, if only because they remind us that when a color is modified by the addition of white, black, or perhaps its complementary hue, it must diminish in intensity. Entirely too much of the lives of many young artists and others has been lost in abortive attempts to produce tints and shades which either do not exist or could not be produced by the colors at hand. A very light blue of great intensity is a myth; but even if it were not, it could not be produced by adding white to an intense blue. And an intense red-purple at its natural value can no more be matched in intensity by a yellow-red of the same value than a crow, made yellow, can be a canary. The truth of this statement will not be affected if the names of the colors are transposed. But in matters of this kind, the pressing question is always the same. How does one learn to recognize differences of intensity and to estimate them with accuracy?

Relative Contrast It is often said, and rightly, that the arts are not concerned with absolute qualities. This is no less true of color qualities than of other kinds, and so it is decidedly more important to know when one color is more intense than another than it is to know the absolute intensity of either. Yet, this judgment rests in the long run on fairly exact points of reference, for to say that one color is

An Irregular Form The Munsell solid seems to have evolved from a naked desire to correlate the basic scales for measuring hue, value, and intensity. Its structural core is a vertical value scale of nine regular gradations between black and white. At the level of each gradation, one must visualize a horizontal disc, and arranged about the center of this disc, ten hues in their natural order, regularly spaced. Further, each hue is radial, and each, as it extends outward, is identically graded to express increments of intensity. When the radiuses—yellow, for instance—lie in the same vertical plane, the solid is functional. In order to find the exact and unique position of any color we simply take a "lift," as it were, to the correct value level, move laterally on the radial line of the correct hue, and continue until the correct intensity has been reached. It is apparent that if the final increment of intensity were the same for each hue at each value level, this solid would resemble an open cylinder, or perhaps a revolving door, with white and black appearing as extensions of its axis at the top and bottom. But each hue reaches its greatest intensity at its natural value level, as we know, and all hues do not reach the same maximum intensity. This makes the solid highly irregular, particularly if we are talking about reflective surfaces rather than light, and the introduction of more intense colors into the solid would have the same effect. Although this irregularity seems to be inherent and unavoidable in a color-naming system, it is not characteristic of the one developed by Wilhelm Ostwald.

The Ostwald System

Ostwald's system is freely acknowledged but rarely understood. In form it is a revival, with refinements, of the double cone of Ogden Rood, mentioned earlier. Certainly it has none of the organic and natural flair which makes the Munsell system so appealing to artists. Moreover it is complex, and one feels that it relys heavily on technology. On the perimeter of its double cones, it shows 24 hues arranged symmetrically about the psychological primaries, red, green, yellow, and blue. The core of the system, a vertical series of six grays, or values, connects the white apex of the upright cone and the black apex of the inverted one. Since the altitude of each cone is one-half its diameter, the solid, bisected vertically, reveals two equilateral, monochromatic triangles, each

with a "full" color in its exterior angle. These full colors are complementary. Each triangle is divided, then, by lines drawn parallel to the sides of the cones, into 28 rhombuses, each representing a specific alteration of its full color. These alterations are produced by adding black or white, or varying amounts of both, to a spinning disc of full color, just as the gradations of the central value scale are produced by adding geometrically increasing and decreasing amounts of white to a spinning black disc. When the hues have been named numerically and the gradations of the value scale have been named alphabetically, the system is operative. For then the color 20-*le*, for example, will be both unique and reproducible.

The Ostwald Formula This color, like any other in this system, can be produced on demand, since the names given to the gradations of the value scale are, in effect, prescriptions. From white to black they are: *a, c, e, g, i, l, n,* and *p.* This means not only that the letter *l* is a value below median, but also that it can be produced by a spinning disc that is 8.9% white and 91.1% black. Similarly, the value *e* can be produced by a spinning disc that is 35% white and 65% black. As indicated on the color circle, the hue 20 is green. It follows, then, that the color 20-*le* will be produced if two radial slices of color, a white one representing 8.9% of the surface and a black one representing 65%, are added to a spinning disc of this particular hue. The hue would represent 26.1% of the spinning surface in this instance, and the result, not unexpectedly, would be a green of median value and moderate intensity. In each monochromatic triangle there are 28 colors, and in the entire solid, 680, all producible by prescription, and there is no reason to doubt Ostwald's statement that every conceivable color has a unique and relational position in this solid.

Still, the Ostwald system has not caused much artistic adrenalin to flow, for with few exceptions the artists of this century, particularly in America, have rejected it. This is not to imply that the system is misguided and useless, but simply to say that to artists it does not seem to provide easy access to the names of colors and to their dimensional relationships. They are not convinced, apparently, that it is a stimulating or practical tool.

Artists and Systems To be sure, much of this disaffection can be attributed to a skepticism of systems which is characteristic of artists. It is obvious that artists are continually asked to make professional

20

judgments in which variables are abundant, and that they arrive at conclusions by intuitive, tentative, and random routes. It is clear, too, that the intent of any system is quite the opposite, since it hopes to lead one to decisions directly and authoritatively. With this in mind, we should not be surprised to find that most artists take a jaundiced view of any system which presumes to predict the quality of subtle, sensory relationships in art, and think that it is either naive or misleading. They are inclined to accept Ostwald's system as a practical scheme for specifying and reproducing colors, and at the same time to reject the dominant aesthetic features of his system. The most unusual of these is a complex of colors formed by four intersecting lines in the solid, which he calls a "ring-star." One of these lines is the circumference of a horizontal circle, and the others are straight. With the circle centered, this figure suggests a band from which three beams of light are radiating, and if we accept the advice of the system, the colors which lie along these diverging lines are harmonious with the one which lies at their point of intersection and with one another.

In each ring-star there are 38 colors, and they are without question related. Those which lie on the ring are different in hue but of the same value and intensity. Some differ progressively in intensity while others differ in value and intensity as controlled increments of black and white are added or subtracted. Presumably these colors are harmonious because they change dimensionally and in disciplined progression. But the artist does not choose colors merely because they are dimensionally and systematically, and therefore, harmoniously, related. He chooses them because they are consistent and sympathetic with his intent and sensually satisfying as well. This kind of harmony cannot be purchased at the corner drug store with a prescription, and it defies the dictates of any system. To see dimensional relationships and exploit them is one thing, and to abdicate to them one's right to make aesthetic decisions is quite another. For if a color-naming system has any aesthetic validity, it must add to the artist's resources by providing a tool with which to understand extraordinary color relationships and to seek them.

Identifying Colors

In refining and explaining his color system, Albert Munsell also felt obliged to make aesthetic claims for it. It would be unfair,

however, to let this detract from the genuine virtues of his system. One of these is that it is organic, so that although the external shape of his "solid" is irregular and unpredictable, the internal forces which generate it are not. The system is like a compact universe in which colors are fixed stars, and if there are any apparent complications, they probably arise from the fact that a system is a concept, not an object. A color is not actually three-dimensional, and when several persons who understand the system are asked to produce a visual summary of it, they will usually draw or construct different models. Despite its simplicity, the system is capable of expressing the finest color distinctions in all dimensions. Its ten hues could be expanded to one hundred, and its nine values to nineteen, if that were desirable. Since it is not, the solid consists of the basic hues: red, yellow-red, yellow, yellow-green, green, blue-green, blue, blue-purple, purple, and red-purple. Its value gradations, excluding white and black, are named numerically, one through nine, and its intensity gradations are similarly named: 2, 4, 6, 8, 10, 12, 14, and so on. We can safely assume that if a color is named "red, value 3, and intensity 10," it is the only color which can be so named, for in a spatial system, two colors cannot occupy the same position at the same time. This being so, any two colors which differ in any dimension are necessarily different colors.

Specifying Colors Recognizing that a name like "red, value 3, and intensity 10" is cumbersome, Munsell proposed that the names of all colors be abbreviated. Accordingly, the color just described is R 3/10. This, incidentally, is the color popularly called Lucretia, probably in ironic tribute to the renowned lady of the Italian Renaissance who regularly spiked the family wine. As one might expect, it is a rather dark and intense red, and resembles a deep, red wine. All this serves to remind us that colors often have several names instead of one, and that these names are not equally descriptive. The name Lucretia has intriguing historical overtones, but it is not sensibly descriptive. For who knows the true and constant color of wine, or of blood, or of any "thing," for that matter? The term "red, dark, and strong" evokes a more positive visual image, but it too is inexact. Even though the hue "red" must lie between red-purple and yellow-red and contain no suggestion of either, the meaning of the phrase "dark and strong" is uncertain. Asked to produce a red which is dark and strong, few will answer with the same color. On the other hand, the name R 3/10, while it lacks the connotative and emotional appeal of the others, is

definitive. In the context of the system, it has one meaning only, and when asked to produce a facsimile of it, those who are acquainted with the system will respond with colors which are virtually identical.

The Importance of a Color-Naming System

It must be self-evident that the ability to name colors on inspection, and the skill to produce fair approximations of colors which have been named, are basic to performers in the visual arts. Without them an inquiring approach to the problems of color can only be ritualistic. And they are no less critical because they are so often honored in the breach. What is not self-evident, however, is the effect of these skills upon the artist's predilection for certain colors, upon his conception of color as a structural element in his work and in the work of others, and upon his ability to adjust and refine color relationships. Between *naming* colors and *seeing* them, there must be a correlation. And yet anyone who contends that we cannot see and relate colors unless we can name them precisely will be totally silenced by history, for epic works of art have been created in color by men who possessed little, if any, formal knowledge of color. In order to resolve this contradiction, one must take the view that extraordinary talent would not be denied, not the view that it chose to be uninformed. Surely the great colorists of the past learned to identify, manipulate, and organize colors in the only way then possible, which was to add perceptive intuition to an awesome amount of experience, and stir well. But this too is history, and there is no need to repeat all of it. A system for naming colors now exists, and it embodies a concept of color which stimulates the imagination without offending the intellect.

A Naming System is a Map
Sensitively applied in the arts, a naming system can illumine our approach to color relations. It can, for instance, suggest answers to the difficult and important question of why colors "hang together," or do not. It can do this and other constructive things only because it contains the ingredients of a language about color. No one believes for a moment that the Munsell system, or any other, will make geniuses of the mediocre or make magicians of the inartistic. Nevertheless, the ability to name colors prepares us to summarize color decisions once they have been made, and to make intelligible judgments about them—and this artists must

do regularly. It must be said that this ability no more precludes the imaginative and intuitive use of color in works of art than the ability to manipulate mathematical symbols restricts creative, scientific thought. It may, in fact, make more colors more accessible, and cause us to use colors simply because, as the mountain-climber says of his mountains, we know that they are there. A color solid is, after all, a special kind of map. It not only tells us where a given color is and how it can be named, but also how its name can be changed. It effectively places all colors so that their interrelatedness cannot be ignored, and so that each color is like a stroboscopic interval in a series without end.

Colors and Surfaces

Surface Color is Elusive

But a naming system is not really viable unless it can be made into a convincing object, and in making the Munsell system into a believable solid, we will make an arresting discovery. We will discover that there is absolutely no fixed relationship between a surface and its color. It is true that every color has a simple identity, unique and describable, and that every surface is colored. Nevertheless, it would be a mistake to assume that every surface has a specific color, and that its color is eternal until it is purposely changed, for this assumption does not square with experience. Almost any three-dimensional object which represents the Munsell system will be constructed of planes, and will no doubt have painted surfaces affixed to it. It is likely, also, that these colored surfaces will be obliquely positioned, so that when the object is turned on its vertical axis they will change, darkening and even shifting unpredictably in hue and intensity. This erratic surface behavior is not peculiar to color solids, of course, for it can be observed in the color of all objects, natural and otherwise, as their surfaces turn in illuminated space. Two leaves taken from the same tree may be identical in color, but if one is returned to foliage which is in sunlight and the other to a region which is in shade, they will be different in color and different from each other. Since this is not an isolated instance, naming the colors of surfaces may well be a problem in perpetual motion.

When in the arts we name colors, we are most often referring to the colors of surfaces. Specifically, we are more often than not referring to the colors of pigments, since a pigment is merely

another kind of surface. And so, if the relationship between a surface, or a pigment, and its color is not one-to-one, it is in the interest of those who must use color to know precisely what it is. This is true even though unintended and quite unexpected alterations in surface color are not always harmful. It can be argued that the color changes which occur rhythmically and continuously in natural surfaces are psychologically beneficial. No one can seriously reply that they do not give vitality to what might otherwise be a sterile, static, or depressing environment. But if the instability of surface colors is not always disconcerting. it is not always agreeable, either, for in the visual arts a change of color which is misunderstood or unanticipated is potentially disastrous. Few artists have been spared the anguish of producing an ambitious work in one place and seeing it in another, its colors capriciously readjusted and its intent corrupted. Still, the artist's fervent wish to the contrary, surfaces can and will change in color, and the problem in the arts, as elsewhere, is to anticipate the nature of this change. It can be done if we learn first why surfaces are colored.

Why Surfaces are Colored

It seems that surfaces are colored, first of all, because they reflect light discriminately. Deflecting and dividing the light which reaches them, they absorb some and reflect the rest. They are colored, secondly, because the light which they reflect stimulates receptors in the retina of the eye, activating the optic nerve and the neural network which connects it with the brain. A surface is colored, then, when these two events, one external and one internal, are joined as an experience. And since in the final analysis it is not the eye, but the mind, which sorts out lightrays and perceives color in surfaces, we may assume that the color of a surface is a perceptual response to light. This is so often the case, that we are inclined to accept color as synonymous with light, and to forget that color sensations can be produced independently of light.

Color Sensation and Light

Pressure on the eyeball, shock, drugs, and in rare instances, sounds, can produce generalized and persistent color sensations. This must mean that color can be experienced in the absence of light. We know, also, that light, or at any rate, its physical equivalent, can be proved to exist when it is not being experienced as color. Nevertheless, the relationship between light and color continues to be a classic metaphysical question. There are those who hold, in the classic analogy, that when a tree falls in a remote

25

part of the forest and is not heard to fall, it nevertheless makes a sound. They contend that the tree made a sound which was not heard. Those who disagree, believing that sound is sensation, contend that the tree could have made a sound but did not. Perhaps it is a circular argument in which the contenders are chasing their own premises. And yet, what is a sound? And similarly, what is a color? If a flower matures and unfurls but is not seen, is it colored? Is a red rose, when we have turned away from it, still red? Possibly these questions are unresolvable. But if we are unable to prove that when we close our eyes all surfaces are without color, we believe that we know why, when we see them, they are colored. They are colored because surfaces react to light discriminately, or selectively, and are not passive reflectors.

It is odd, and perhaps difficult, to think of surface color as a reaction to light, for the common view of surfaces is that they are both inanimate and inert. But the case is quite plain. Natural illumination—sunlight—contains all visible wave elements and potentially contains light of every color. However, natural surfaces are not every color. And so if natural light is potentially every color while the surfaces which it illuminates are not, we can only deduce that these surfaces act upon light. Only this conclusion explains why natural surfaces are so varicolored, and why, when imbalances occur in natural light, as they do unceasingly, these surfaces are modified in color. Be assured that this conclusion is more than a desperate hope, for the light which reaches a surface can be analyzed, as can the light which is reflected. In all instances, the light which is reflected is less, and except in the case of white, black, or gray surfaces, of a different character. Add to this the fact that if several differently colored surfaces are observed in the same light and their wave-reflection analyzed, each clearly will reflect a distinctive and different part of that light. Presumably, the lightwaves which have unaccountably disappeared in these analyses have been absorbed as heat, for we know that as a surface reflects less light, its temperature rises. We may say confidently, then, that a surface is colored because it *reflects* lightwaves selectively, or on the contrary, because it *absorbs* them selectively. It acts upon light, subtracting some and reflecting the balance. And this balance is its color.

Illumination and Surface Color It is further true that the reaction of a particular surface to light is constant, so that when a surface changes color it is not because its capacity for reflection has changed. This is interestingly

illustrated when blue and yellow pigments are mixed to produce a green one, for unlike old generals, the mistaken notion that blue and yellow pigments produce green by addition simply will not fade away. A blue pigment predominantly reflects lightwaves called blue, and simultaneously reflects varying amounts of nearly all types of light, including green. A yellow pigment, too, reflects additional types of light, and when these pigments act upon incident light in concert, as they do when mixed, the color which they reflect dominantly is green. The originally dominant blue and yellow waves are absorbed reciprocally, the yellow pigment absorbing an extremely high percentage of the blue waves and the blue pigment absorbing most of the yellow ones. Although they produced a new surface and a new color, the individual reflective traits of the blue and yellow pigments did not change. This says that every pigment has a spectrum of reflection which determines both its color and the colors which it can produce in collaboration with other pigments. But there is another reason why the spectrum of reflection of a given surface does not appear to be constant. If the color of a surface is indeed the sum of its reflected light, it follows that the color of that surface might be affected by an alteration in the quality or compostion—which is to say, in the intensity or spectral balance, perhaps—of its illumination. It will be, too, and any one who works with colored surfaces must recognize that a marked change in the quality of the light from which they extract their color will cause them to change, sometimes drastically. This precarious dependence justifies an even closer look at the way in which surfaces act upon their incident light.

Surfaces Reflect Selectively and Unselectively

As already intimated, a green surface predominantly reflects the waves in incident light which produce that color sensation, and assuming balanced, or white light, also reflects lesser amounts of those which produce the color sensations yellow, yellow-green, green, and so on. Like all chromatic surfaces, it reflects selectively, and to the extent that it reflects green rather than other hues, it will be intense and of median value, the natural value of green. If for any reason it begins to reflect less green light selectively, it will become darker and less intense. And if it begins to reflect more of other hues while continuing to reflect green dominantly, it will become lighter and less intense. These predictions are verifiable. They are based, first of all, on our understanding of the way in which achromatic surfaces act upon light, and this is no mystery. Achromatic surfaces are the hueless

27

surfaces called gray whose extremes are black and white. It has been established that these surfaces, and white ones as well, reflect all lightwaves in the proportions in which they are present in white light. Black surfaces absorb all lightwaves, of course, and so white, gray, and black are said to reflect and absorb unselectively, or indiscriminately. Most surfaces called white are not brilliant and clear, and most black ones are cloudy, but this happens because surfaces reflect and absorb with notorious inefficiency. Even the whitest painted surface may absorb as much as twenty precent of its incident white light, while the densest black surface may reflect about five percent. Although the behavior of achromatic surfaces is slightly erratic, we may nevertheless say that they vary in color according to the quantitative balance which they strike between light unselectively reflected and light unselectively absorbed.

Why Surfaces Change in Color

Reflection and Change

All surfaces reflect some light unselectively, which is to say, in the relative amounts in which they are present in white light, for if they did not, many surfaces would be as intense in color as spectral light itself. It has already been noted that chromatic surfaces reflect light selectively, and thus acquire their specific hues. It is, then, in the balance between these mutually exclusive kinds of reflection that a surface acquires its color. There remains, nevertheless, the question of how a surface acquires its particular dimensions, and why these dimensions vary. The answer is that its hue is determined by its capacity to reflect selectively, its value by its capacity to reflect both selectively and unselectively, and its intensity by the ratio between these two kinds of reflection. Anything which affects one or more of these conditions in the surface will automatically cause its color to vary. All this is fortunately less complicated than it sounds, and is easily illustrated. A light, intense red surface reflects a great deal of light totally (its value), reflects more red waves than any other kind (its hue), and reflects considerably more red waves than all other kinds (its intensity). It is not at all difficult to see that when a change occurs in the light upon which this surface acts, the surface must change in some degree. That it must, in other words, become a different color.

Illumination and Change

A surface cannot, in any event, reflect lightwaves which are not present. However, it can, like a receiving station, react to any

perceptible change in the composition of what is transmitted. That is why, when an intense, green surface of median value has become darker and less intense, we can say that it has begun to reflect less green light. For when that surface reflects less green light it necessarily reflects less light totally, to become darker, and less green light in relation to the light which it reflects un-selectively, to become less intense. Color changes induced in surfaces in this way—that is, by natural or contrived alterations in their incident light—are always interesting because surfaces react to this kind of change distinctively. The range of this reaction can be seen clearly in the behavior of two representative surfaces, one magneta and the other green. When an appreciable amount of green light has been removed from the illumination on these surfaces, the magenta one is scarcely affected. It absorbs virtually all green light, anyway. The green surface, on the other hand, is wholly neutralized as it becomes darker and strikingly less intense. This is an extreme case, to be sure, but it is not extraordinary, and it tells us in plain experience that when the illumination on a multicolored surface has been changed, the color relationships on that surface have been changed, also. A painting is, of course, such a surface. But even if all illumination were suddenly and constantly the same, we would find, to our consternation, that the colors of surfaces and of painting were not.

A surface can change in color because its physical or chemical nature has changed. This happens when a metallic surface rusts, a dyed one fades, and an organic one ages. It happens, too, when a raw surface is painted. And a surface can change in color because it has been placed in a different environment, in which case its apparent relationship to other colored surfaces has changed. The implication, when we have added this last potential cause of change to the others, is stunning. For if the color of a surface can change in a variety of ways as well as for a variety of reasons, the absolute color relationships about which we hear so much in art may well be a severely overworked myth. But while surfaces can and will change in color for many reasons, most changes are induced by illumination, as when artificial light is substituted for natural light, or one kind of artificial light replaces another. By far, the greatest number of changes of illumination occurs in natural light. This may be somewhat surprising, for when we want to know the "true" color of things, we usually examine them in natural light, or daylight, on the assumption that daylight is constant and therefore reliable. This

assumption is much honored and is not about to die. But it must be obvious to those who are even modestly observant that natural surfaces are swept up in change which is endless and cyclic.

Color and Natural Light

The relationship of the sun to the things which it illuminates is never static, for as the sun moves—or more accurately, as we do—its angle of illumination either increases or decreases. The result is a gradual and relentless change in the perceptual patterns and colors through which we come to terms with the visual world. In addition, much of the visual world is itself in motion, so that the variety and complexity of these patterns and colors can only be described as awesome. Certainly, if we have watched the shadow of a cloud move ponderously across a river valley, driving the sunlight before it, we know how subtle, magical, and mercurial such patterns can be. We may rarely reflect, however, on the nature of what we have seen.

We may take the simplistic view that a cloud is a distant, moving object in the sky, and that it interferes with sunlight on its way to earth. By refracting and diffusing the sunlight, it creates a vast pocket of distilled light between itself and the surface of the earth. This modified light produces a change of color in those areas of the earth's surface illuminated by it, and we, in turn, see the shadow of the cloud. There are those who find such over-simplifications offensive. But it surely must be true, for instance, that on a day in which the sky is overcast we actually live in the immense shadow of an imperceptible cloud. Having been so immersed in it, most of us are acquainted first-hand with a cloud-shadow and its light. Still, the light of a distant shadow is more luminous and its effect less oppressive. This must be because it is in some measure affected by the density of the cloud, the position and intensity of the sun, the distance of the cloud from earth, and even the clarity of much of the sky itself. While we cannot know the exact composition of this light as it is subjected to one of these influences and then to another, we do know that as it touches down to make a shadow, the surfaces which it touches will instantly become darker and less intense, though not uniformly. They will change in hue, too, as the light of the sky asserts itself, and become more blue. And just as we know that the same man cannot step into the same river twice, we know as we watch the

shadow of the cloud glide immutably across the valley that this show, in all its particulars, may never be repeated.

Filtered
Natural Light
The shadow of a cloud is a singular and perhaps dramatic example of the way in which atmospheric interference can affect the colors of surfaces. But sunlight is interfered with in other ways, and often. It is, for instance, regularly intercepted and changed by minor concentrations of moisture and dust particles in the atmosphere. Under the right circumstances, a rainbow will bend its way across the sky. This kind of interference is most startling, however, when the sun is low in the sky so that its light, striking through the atmosphere obliquely, is systematically scattered. Then, the indigo rays which, along with the green and red ones, produce the hues purple, red-purple, blue, and blue-green, are filtered out by refraction and lost. This action restructures the sunlight, and one need not be a crystal gazer to foresee that it will have theatrical results. One of these is the songwriter's romantic "red sails in the sunset." Having seen a few such fiery improvisations, we realize that the sky, with its atmospheric sediment, is a massive filter lying between us and the sun. Although we are more aware of this filtering action during climactic moments, as when the sun rises or sets, or a storm broods on the horizon, we must accept the fact that it also creates what we casually call daylight, or white light, and does it in about the same way. It is because conditions in the sky are so subject to change, that daylight is simply the kind of light which we are accustomed to or will accept. And it is often an astonishing kind of light.

If we responded to every color change induced in surfaces by the action of daylight, we would shortly be exhausted by the visual and psychological ordeal. And so, psychological stability alone may demand that we dismiss irrelevant and useless color changes, just as we screen out irrelevant and distracting sounds, smells, contacts, and so on. It follows from this that even though daylight varies continuously and the colors of surfaces change in the same deliberate rhythm, a surface has not changed in color until someone perceives that it has. It seems that we not only tune *out* changes which we feel are irrelevant, but that we also tune *in* those in which we have a positive interest. There are, then, those for whom color changes are frequent and many others for whom they are uncommon. But it is one of the tenets of education in the visual arts that color sensibility, which is surely a refined response to "difference and change," must be cultivated.

31

Cultivating an Awareness of Change During the last century and in the first decades of this one, when artists were concerned en masse with the transient qualities of natural light, the ability to dramatize light in landscape painting was a revered gift. In that period an artist's awareness of the phenomenal nature of daylight, or modified sunlight, was a "must." This had a stringent effect upon the training of artists, as one might imagine. It was routine to ask a young artist to produce a series of summaries, or studies, in which he painted the same simplified landscape at sunrise, midday, and sunset, or in sunlight, rain, and mist. These studies, when successful, showed unmistakably that the elements in a landscape change in color without apparently having done so. They showed perhaps that a muddy and rain-swollen stream continues to look fairly dark, unintense, and yellow despite atmospheric changes which we know have caused its color to change. Its color is apparently unchanged because all other colors were similarly affected; for if the artist painted the changing context in which the stream appeared, he found each time that the color of the stream had to be modified if it were to look yellow, fairly dark, and unintense. In many cases, these summaries contained areas of sky, but the most instructive did not, and demonstrated clearly that it is the color of the whole, not merely the color of the sky, which describes daylight. Still, such practical exercises had to make the artist forever sky-conscious, and had to make him especially sensitive to color changes which others either did not recognize or did not think were relevant. That was their purpose, and it is even now honored, but for nonaesthetic reasons, by those who work the land and live close to the caprices of nature. The farmer knows, for instance, when a storm is quietly winding up for an attack, even though if we ask him he does not know precisely why he knows. Maybe he does feel it in his arthritic elbow, maybe he does feel it in the air, and maybe he does smell it, but no doubt he *sees* it in the color of everything about him, including the sky. This is not an appeal for a return to the glory days of landscape painting, for a tarnished glory is worse than none. But it might well be an appeal for more awareness, in artists and in others, of the variety, complexity, and fascination of natural color.

It is fair to say that most of us have immunized ourselves to the color nuances which are alive and dynamic in nature, responding to them vaguely if at all. But if we must screen out most color changes in our own psychological defense, who can say which of these should be relevant and at which point we should be sensible

to difference and to change? No one can say, of course, but there is also no present danger that we will respond excessively to any visual change, whether confronted by it in nature or in art. We are rarely so attentive that we perceive the hues of those varicolored and familiar images called trees, whose "gray" branches are a subdued blue in skylight, a dark red in the shadows created by their leaves, and a surprisingly intense yellow in those areas in which sunlight seems to flutter. This being so, we are predictably oblivious to the changes which will, within the hour, make these same surfaces gray, red-purple, and blue-purple. Possibly we are insensible to these changes because they are more relevant to squirrels, sparrows, and artists than to other folk, but it is more probable that familiarity has again bred indifference, if not contempt. In any case, we cannot be indifferent (unless for other reasons) to those artificial changes of color which are blatantly contemporary and unexpected, and which underscore the very real distinction between surfaces and colors. They are not familiar! And they cannot be irrelevant, for they are in some degree making the sun visually obsolete.

Color and Artificial Light

Artificial illumination has lengthened the day and will in time bind a new environment to it. Although the latter is speculation, it is not idle; for there is reason to suspect that Shakespeare's figurative phrase, "All the world's a stage," may turn out to be prophetic, and that the diameter of the theater-in-the-round will one day exceed our most irrational expectations. For even now we are not startled to find, as we drive into the amber haze of a turnpike plaza, that its light has transformed our companions into bizarre impersonations of themselves. Nor are we stunned to see a ghostly illuminated cathedral, its facade swimming in light from a dark nowhere and its spires softly touched with color. And we are no longer surprised as circus riders in the center ring, poised on the broad backs of thumping horses, flash by in brilliant, surrealistic colors. These exhilirating experiences and others like them suggest vividly that traditional lighting has surrendered to alternating beams and colored filters. But if such experiences are truly different from natural ones, it is not because their contrasts are extreme but because they are abrupt. They are abrupt, of course, because artificial light is adjustable and controllable, as the sun is not.

Transmitted Color

White light, which is balanced light, has been defined as sunlight reflected from a white cloud at noon on a clear day, and so we may be sure that artificial light sources are most often unbalanced. That is, they do not generate lightwaves in the proportions in which these waves are present in white light. Nor do all artificial light sources generate the same spectra. Moreover, as in the illustrations just cited, the spectra of artificial light sources can easily be changed. When a red filter is placed between a balanced light source and ourselves, the light which it transmits is red. It is apparent that the filter, which is a uniformly thin and translucent film, not only transmits the waves which are red but also destroys all others. Actually, it absorbs the others, or most of them. And since we know that surfaces acquire their color by reflecting selectively, we might expect the surfaces seen in this light to look red. This simplistic logic no doubt spawned the timeless vaudeville gag in which a clothing salesman whispers to his assistant, "Get the blue light, the man wants a blue suit!" The line contains enough truth to make it amusing, for when a multicolored surface is illuminated with red light, those surfaces which were either red or hueless will continue to be red or will assume the color of the light. Surfaces not previously red will certainly incline toward red, so that a light, intense yellow surface, for instance, will become a yellow-red one, darker and less intense. Contrasting surfaces such as blue and green ones will become much darker and less intense, and blue-green ones will become black. That colors which were red should continue to be red, that formerly hueless colors should become red, and that all other colors should in varying degrees resemble the color of the light is intuitively acceptable. But why should blue-green surfaces become black? And why, when a blue-green filter has been added to the red one, should all surfaces become hueless and black?

Filters Act upon Light

A red filter, acting much like a red surface, reacts favorably to the red component in light and negatively to the component which is totally different from it, the blue-green one. It reacts negatively by absorbing and effectively destroying those lightwaves which produce the color blue-green. And so the effect of turning a red-filtered light upon a blue-green surface is fairly predictable. Since this surface acquires its color by reflecting blue-green lightwaves and absorbing red ones, and since there are in the light no blue-green ones to reflect, we can expect it to reflect nothing and to be black. In this case, the filter has absorbed about one-half of the available light and the reflecting surface has absorbed the rest.

34

And when red and blue-green filters are used simultaneously, the effect is the same, for then the lightwaves reflected selectively by the one are absorbed selectively by the other. This is not to say that any combination of two filters will absorb and destroy all light, for this is characteristic only of complementary hues. But it must be apparent that all filters "subtract" selectively from light sources and restructure them. That is why filters are used so extensively in photography, usually for technical reasons, and in the theater. Since designers in the theater are fundamentally concerned with creating imaginative and appropriate environments, one of their principal elements must be light, and one of their principal tools, the gelatin filter. But whether light is used for technical or aesthetic purposes, those who are knowledgeable can modify its contrast at will and change the colors of surfaces at the flip of a filter.

Filters Reveal Color Relationships

Simple experiments with filters will confirm what has already been said about surfaces and the way in which they act upon light. They will demonstrate repeatedly that surfaces are not inherently colored, but have the capacity to become colored and that this capacity is exercised, or is not, according to the quality and quantity of their incident light. But filters can also reveal basic color relationships in light and therefore indirectly, in surfaces as well. They can reveal, for instance, that the colors red, green, and blue (violet) are primary color ingredients in sunlight, or white light. For when all of these colors have been subtracted from white light, there is, finally, no light; and conversely, when they are brought together again in about equal amounts, the instantaneous effect is to produce white light. This phenomenon has been demonstrated too often to be dealt with in great detail here. It is sufficient to say that the demonstration involves the use of three projectors and three filters, each filter corresponding in color to one of the primary colors. White light is produced by superimposing these colors on a white screen, and black light, or no light, is produced by placing all three filters on one projector. The meaning of the demonstration is remarkably enhanced when the primary colors are projected as overlapping pairs, in which case, red and green will produce yellow, red and blue will produce magenta, and green and blue will produce blue-green, or cyan. It is then logical, since each of these new hues is constructed of two primary ones, that the addition of the remaining primary color should produce white light. Red and cyan (red, and blue plus green) are two such related colors, and they, and others like them,

are said to be complementary. As those who are even slightly acquainted with the language of color must know, the words *primary* and *complementary* and the concepts which they represent are pivotal. They are pivotal because they refer to relationships which have traditionally provided a rationale for fragmentary assumptions about color and for the development of fairly elaborate color systems. Although the value of most of these systems is debatable, the significance of primary and complementary color relationships is definitely not. They are, as we will see, a link between physical stimuli and perceptual response, or between lightwaves and the recognition of them as color, and it is plain that they are the internal order which causes colors to be related.

Why Red, Yellow, and Blue?

We hear again and again in the arts that red, yellow, and blue, all of extraordinary intensity, are primary colors. We hear, too, that since these colors are primary, they can be used in pigment mixtures to produce all other colors. It is difficult to decide whether this is a half-truth, a misconception, or a sentimental myth. Red, green, and blue are also said to be primary, and although red, yellow, and blue pigments when mixed will indeed produce colors of every hue, they will not produce every color. It seems, then, that red, yellow, and blue are not the only primary colors, and that, rumors to the contrary, they will not produce all other colors. If these three colors could produce all others, artists would not adopt such individualistic and eccentric palettes. In what sense are these colors primary, then? It is probably true that if an artist is restricted to a few pigments, he will settle for a red, a yellow, and a blue, all of high intensity. He will accept them because they look elemental, or "pure," and because they will produce all other hues in some form (see Plate 2). Mainly, though, he will accept them because they are the particular hues which he believes he must have in order to be effective. He must be willing, then, to sacrifice quantity and variety for special effects, for in the idiom of the visual arts, pigments "mix down." This means that an intense color simply cannot be mixed unless we use two others which are lighter and even more intense. Anyone who decides to mix an intense red, or yellow, or blue, even with colors which are hue-related, has found a lifelong avocation. And so the artist who opts for the primaries red, yellow, and blue, has at the same time elected to delete intense green and purple, and related hues, from his palette.

But the notion that red, yellow, and blue are primary has not persisted so long simply because they are pure colors, for green is also pure; nor simply because they will produce all hues and many colors when mixed, for red-purple, yellow, and blue-green will produce many more; nor even because most artists think they need these colors in order to function, for many artists may think otherwise. It has probably persisted for all of these reasons, plus one—the apparent primary symmetry of these three colors. But on close inspection, this symmetry is less than real. Red plus yellow equals yellow-red, and yellow-red and blue are complementary hues. We know that any two colors which are complementary will, when mixed as pigments, produce colors of diminishing intensity, and finally, of no hue. In the days when color "schemes" were tolerated and even respected, this one was called a split-complementary triad. Complementary colors, if there are three, will create three such split-complementary triads, all interlocking and symmetrical. And each of these colors, when mixed in roughly equal concentrations with the other two, will produce a hueless color, and possibly, black. This is characteristic of primary pigments but not at all characteristic of primary lights, and the difference is critical as well as interesting.

The Physical (Light) Primaries

The physical, or light primaries are the colors red, green, and blue. More specifically, they are a red which inclines toward yellow-red, a green which is symmetrical, and a blue which might more accurately be named blue-purple (see Plate 2). Mixed in varying proportions, as light, they will produce all other colors, and mixed in approximately equal amounts, they will produce white light, or no color. Since color sensations are not evoked by lightwaves of a specific length but by a bundle of waves of similar length, no truly precise physical definition of these colors, or of others, is possible. Nevertheless, the red, green, and blue which have been described are apparently capable of producing all colors, and are accepted unquestioningly as the physical primaries. However, with the exception of green they are not visually pure, and one may ask why yellow, admittedly so essential in works of art and in pigment mixtures, is not among them. There is in white light a narrow range of lightwaves which evokes the color sensation yellow, but this color is mainly produced,

anyway, by a mixture of those lightwaves which separately produce the color sensations red and green. This phenomenon is still unexplained, although it can be verified easily enough by projecting red, green, and blue lights onto the same white surface. The surface will become red, and then yellow, and with the superimposition of the blue light, white again. This will, incidentally, confirm the additive nature of these primaries once more. But this quality can also be demonstrated if all three colors are affixed, as painted surfaces, to the same spinning disc. This technique has the added virtue of allowing us to appreciate both the subtle distinction between additive and so-called visual color mixtures and the not-so-subtle distinction between additive and subtractive ones.

Visual Mixture

Delayed
Retinal Response

The discs used for the purpose of mixing the light from surfaces are formed so that they can be spun in combination. They are called Maxwell discs, and each looks like a phonograph record, thin and fairly rigid, with a radial slit extending from its center. It is possible, when two or more of these discs are of the same diameter, to interleave them so that a fractional, pie-shaped section of each is visible. Painted and combined in this way, they can be clamped to a vertical turntable, and spun. If the discs are spun at speeds in excess of 50 revolutions per second, the light reflected from their differently colored surfaces will be undifferentiated and will create a new color, which will be evenly diffused over the area of the discs. Roughly equal sections of the primary colors red and blue will produce the hue red-purple, or magenta. But this color will not emerge because the light from all areas of the disc has fused, as one might think, but because the receptors in the retina are unable to react with sufficient speed to individual messages. Color sensations persist as afterimages for as long as one-third of a second, and in the case of intense colors, longer. Consequently, as the multicolored disc spins rapidly, the retina is stimulated by a second color before it has completely reacted to the first. This tells us that when we see red and blue become magenta, it is because we can only respond as if to the alternating, overlapping, and therefore, simultaneous, bombardment of these two colors. We are similarly affected when any two colors are brought together as adjoining areas which are so small that one cannot be perceived to the exclusion of the other.

This is the principal device of Impressionism, and particularly of that phase of it called scientific.

Visual Mixture
and Impressionism

Anyone who has seen the best Impressionist paintings is familiar with the white, scintillating mist which hangs over their surfaces. This haze is pronounced when we are far from the painting, and is no doubt the cumulative effect of unselective reflection. It burns off as we move closer to the painting and reach its pointillistic, or mixing, distance. Pointillistic mixes and others like them are said to be visual because the viewer, unable to differentiate and see the colors—blue *or* yellow, for instance—fuses them and sees the colors blue *and* yellow. Undifferentiated light from blue and yellow surfaces will, if their areas are about equal, be white. It seems, then, that color mixtures are "visual" when the light from their elements is summarized in the observer. And it seems for this reason that such color mixtures have a separate perceptual existence. For when the colored discs have stopped spinning, or when we have moved in on a pointillistic pattern so as to change its scale and effectively destroy it, the original surfaces are visible and unchanged.

Additive and Subtractive Mixtures

Light Added
or Subtracted

It is fair to say that a color produced by visual mixture is highly subjective, or in present-day jargon, optical. The same cannot be said of one produced by addition, as when red-purple is produced by projecting and superimposing red and blue lights on a white screen. Naturally, the red-purple produced when these lights are observed directly will be more intense and completely additive, for a white screen always reflects some incidental white light. But this interference is unimportant, and when the red and blue lights are projected as overlapping circles, it is clear that the red-purple created by overlapping is more luminous than the red and blue which flank it. This suggests, certainly, that the red-purple light is quantitatively greater as well as qualitatively different, and further, that it may be the sum of the red and blue lights. This is so. But if we mix the same red and blue colors as pigments, we will suspect at once that nature is indeed perverse. For the resulting color, though red-purple as expected, will be decidedly darker and less intense than the one produced by addition. This is not an illusion, and to prove it one merely produces a red-purple by affixing a red and a blue to a spinning disc, and then, using the

same red and blue pigments, produces a red-purple. The second color will be unbelievably darker than the first, which was produced by an additive, visual mixture, and even a dedicated skeptic will concede that light has been lost. This loss, in the language of color, is said to have occurred by subtraction.

Inasmuch as an additive color mixture produces more light, a subtractive mixture must destroy some. That is, pigment added to pigment must equal more absorption, and consequently, less light. This is the simplest of distinctions, but only if we recognize that absorption, about which much has been said, is *not* subtraction. This distinction is fine, but not obscure. We know that before a blue light can be projected onto a white screen, it must be carved out of a light-source with a filter. We know, too, that the filter functions by transmitting blue light and simultaneously absorbing other kinds. Now, if this transmitted light is further reduced and changed by the introduction of a second, different filter before it reaches the screen, the color projected onto the screen has been produced by subtraction. And since a filter is no more than a film of paint which monitors light, we may confidently assume that what is true of filters is also true of pigments. This has to mean that when pigments are mixed, the light which they then reflect will invariably be less than the sum of their previous, individual reflections—and most often, of a different kind.

To paraphrase Marshall McLuhan, the medium is paint and the message is clear: When pigments are mixed, light in varying amounts is lost. The extent of this loss depends upon the reflective spectra of the pigments, and in turn, upon their chromatic affinity for each other. Complementary colors, for instance, since their reflective spectra are as unlike as possible, have no chromatic affinity; and so when they are mixed, the reflected light of both pigments is totally lost. The result, which is no light and therefore no color, is predictable. In less extreme situations, however, we are continually surprised to find that dissimilar colors produce equally dissimilar results. This happens when a mixture of red-purple and blue-green pigments produces the color blue-purple, even though it is of low intensity. We are regularly surprised, to be sure, but we should not be mystified, for the results of subtractive mixture are foreseeable to those who know how to see.

This digression from the subject of primary colors was intended

to explain why mixing lights and mixing pigments have inverted consequences. It hoped to explain, along the way, why the colors red and blue, for instance, when mixed as lights produce a light magenta of some intensity, while these same colors mixed as pigments produce a dark, unintense magenta. More importantly, it was to suggest that the physical primaries—red, green, and blue—cannot be pigment primaries, too. For even if these colors looked pure, which they do not, and even if they were universally preferred by artists, which they are not, they would be unsatisfactory.

The Graphic Arts Primaries

Red, green, and blue pigments, since each reflects only a specific one-third of white light, subtract rapidly when mixed together. This is emphasized in the technical literature on color, which routinely describes these colors as minus blue and green, minus red and blue, and minus red and green. It is shown also in the fact that when these pigments are mixed in approximately equal amounts and strength, they will subtract totally, absorbing all light, and of course, producing black. They mix to zero because they have no chromatic affinity for each other, for one can prove in a moment that the most intense red and green pigments are incapable of producing a yellow of even middle value and modest intensity. If, then, we are looking for pigments of uncommon reflective strength, these will not do. But these same colors, when mixed as lights, and when mixed so that each pair produces a third color which is intermediate in hue, will produce the colors magenta (red-purple), yellow, and cyan (blue-green), all of extraordinary brilliance. Clearly, each of these newly created colors reflects two primary lights, and a pigment which matches it will do the same. Allowing for the reflective inefficiency of pigments, it will do markedly less; but nevertheless, red-purple, yellow, and blue-green, mixed together in varying combinations and amounts, will produce more colors of all kinds than will any other three pigments (see Plate 2). Their reflective potential is well understood in the graphic arts, where they, along with black, are the colors of the full-color printing process. When these four colors have been overprinted in patterns which have been created by filtering and photographic separation, they produce the facsimiles of paintings and other works which we see everywhere. If we examine the surfaces of these reproductions under a magnifying lens, we will see that they consist of four layers of intricate and stunning reversible dots of color, and that these dots

depend upon both "visual" and subtractive mixture for their effectiveness. We will see that where the minute, translucent dots overlap, effects are produced by subtraction, and that where they lie together as independent colors, effects can be attributed to visual mixture. Mainly, however, the colors red-purple, yellow, and blue-green, when overprinted, produce other colors by subtraction, and it seems that theoretically as well as practically, they should be the pigment primaries. But these three colors will not do, either, and one is left wondering. Why, then, are pigment colors primary?

The Artist's Pigment Primaries

Colors are primary because they are the irreducible means of achieving some end. This purpose anticipates the means, so that if our purpose is to produce every conceivable color by mixing colored lights, those few lights which are necessary are also primary. In the same spirit, if our purpose is to mix all colors by mixing pigments, those few which we must have in order to do so, are primary. In the first instance, the magic number is three, and the colors are red, green, and blue. But in the second instance, the search for primary colors will be futile, for there is no simple combination of pigments which, mixed together, will produce every other color. This being so, the alternatives are obvious, though uninviting. We can compromise in our purpose, or abandon it in favor of a different one. In the discussion, earlier, of the traditional pigment primaries, both alternatives were mentioned. Those who chose those colors settled for some degree of symmetry, some degree of purity, and some capacity to produce colors of all hues. As is always true of extreme compromises, this one has not pleased anyone very much and has not served anyone very well. It is plain, then, that if we cannot have colors which will produce all others, we must march to a different drummer, and have those which we need.

This could mean that every artist will himself decide which colors are primary, and that he may change his mind. He could; but this is neither necessary nor helpful. For if colors are primary because we need them, we will surely need those colors which look indivisible, or pure. Magenta cannot therefore be a primary color, nor can cyan, for one can detect elemental, or indivisible hues in them. These elemental colors are the red and blue in magenta,

and the blue and green in cyan. Everyone agrees that red, yellow, and blue are chromatically indivisible and are, in this sense, primary, but artists almost without exception testify that they see blue and yellow in the color green. Why this should be so is a matter of speculation. But even young artists can remember when the pigment green was so chemically unreliable that they habitually mixed this color from yellow and blue. Nevertheless, there is no doubt that green is a pure color, and that when it is produced by mixing blue and yellow, it is not the sum of these two pigments but their remainder after subtraction. Young artists remember, too, when all red-purple and purple pigments, of which alizarin crimson is typical, were so fugitive and so suspect that one used them advisedly, and if possible, not at all. Now, however, intense green and purple pigments are respectably stable, and by the grace of modern chemistry may soon be as stable as any of the others. And so if green and purple are added to red, yellow, and blue, we will find that these five colors are effective pigment primaries.

Elemental Hues There is no reason to think that the color purple, since it is not in the visible spectrum, is not pure. It certainly looks indivisible, and it is flanked in the spectral band by the impure colors red-purple and blue-purple. It may be true, as some insist, that purple is more susceptible than other colors to slight shifts of hue, whether caused by changes in illumination or in environment. We may say, nevertheless, that the colors red, yellow, blue, green, and purple are chromatically elemental, or pure; that they provide the intense colors which we *urgently* need in the visual arts, as well as those intermediate ones which we *might* need; that they make all hues and an enormous number of colors available through intermixture; and finally, that they are structurally related. The last two qualities are not apparent in the colors themselves. But when these colors, and those which are intermediate, are placed systematically in a color circle, we will find that each intermediate hue is a complement to one of the primary colors. And one soon learns that without this internal sense, the color circle is without any sense at all.

The Color Circle

The color circle which has been suggested is a circle of ten hues. However, elementary circles sometimes consist of only six hues,

and more advanced ones, of twelve. The color circle of Wilhelm Ostwald, described earlier, consists of a staggering twenty-four. But whether it is simple or elaborate, the color circle must present hues in their continuous spectral sequence, and do it in such a way that the contrast between any two adjacent hues is apparently the same. The circle which does this most graphically is one consisting of three primary lights and twelve hues. It first of all circumscribes an equilateral triangle, with the physical primaries—red, green, and blue—in the angles of the triangle. We know that when these primaries are mixed as pairs, they will produce the intermediate hues magenta, yellow, and cyan. These hues, then, will appear on the circumference of the circle, between appropriate pairs of primaries. This done, the circle consists of six alternating primary and intermediate hues, and when six secondary hues have been placed between each primary hue and the one which is intermediate, it is complete. If we think of this circle as a clock face, the physical primaries will lie at 10, 2, and 6 (red, green, and blue), and the intermediate hues at 12, 4, and 8 (yellow, cyan, and magenta). Lines connecting the physical primaries will describe an upright equilateral triangle, and lines connecting the intermediate hues—which are, in fact, the primaries of the graphic arts—will describe an inverted one. This circle with its interlocking equilateral triangles is simple, but it is to the study of certain intrinsic color relationships what the telescope is to the study of the stars. Through it, we hope to look beyond the obvious and to discover why colors, when mixed subtractively, behave as they do.

How Colors Mix The color circle is not functional until there is a gray, or one-dimensional color at its center. For then, when radiuses are drawn to the twelve hues on its circumference, each radius can express gradations of intensity. This means that a line drawn from yellow (at 12) to green (at 2) will intersect the radius yellow-green at a point well below full intensity. Similarly, lines drawn from yellow to blue-green, and from yellow to blue, will intersect this same yellow-green radius at points which are successively closer to the center of the circle. This tells us, in general, that when two hues are mixed, they will produce a third which lies somewhere on the geometric chord connecting them. And it tells us, in particular, that one of the effects of adding blue-green and then blue to the pigment yellow, is to produce two yellow-green colors of decreasing intensity. In both cases, the value of the yellow-green will be lower than the value of the lighter of the two

colors which produced it. This confirms the subtractive nature of pigments once again, and reminds us that when pigments are mixed, they always change—but do not merely change. Like pieces in a game of chess, they move dimensionally, and along prescribed routes. For this reason, the yellow-green colors just mentioned, which can be produced by adding restricted amounts of blue-green and of blue to yellow, can be produced in several other ways.

Discovering Colors

They can be produced by adding a red, and then a yellow-red, to the color green. But since a color circle is a two-dimensional map and colors are three-dimensional concepts, the yellow-green colors produced by mixing these three colors may not be like the previous ones in value. The odds say overwhelmingly that they will not be. We may be certain, however, that some combination of red, yellow-red, and green will produce the colors which we want, and that our assumption is sound. This assumption is that two colors will produce a third if it lies on the line connecting them in the circle, and if in value and intensity it splits the difference between them. These yellow-green colors can also be produced by mixing yellow and green (mixing along the chord), and adding to this mixture an appropriate amount of black, or gray (mixing along the radius). And if we wish to take another route, or must take another, we can add the complement of yellow-green, which is purple (mixing along the radius), to a mixture of yellow and green (mixing along the chord). In this way, we can "draw" the mixture towards the center of the circle, and neutrality. Fundamentally, these techniques are means of producing colors which we want but do not have. But it is *finding* colors, not matching or reproducing them, which is the young artist's preoccupation; and if he is perceptive, mixing along the traces made by chords or radiuses, or by both, will probably lead him to discover colors which he does not ordinarily anticipate or is prone to think are not producible. He is not inclined to think that the color red, for instance, can be produced at moderate value and intensity levels by mixing red-purple and yellow, or purple and yellow-red. And he may never discover, by randomly mixing colors, that such an unlikely combination of hues as blue-purple and yellow-red will also produce this color, although at low intensity. Mixing colors structurally is not more difficult than mixing them randomly, and it is fair to say that, while mixing colors randomly produces more surprises, mixing them structurally produces more revelations.

It is self-evident, perhaps, that when two colors which lie on the color circle are mixed in varying proportions, they will produce the colors which lie on a line connecting them. It is apparent, too, that when they have little chromatic affinity for each other, they will produce several hues in the process. When, for instance, yellow-red is added to blue-purple in increasing amounts, it will successively produce the hues purple, red-purple, and red. If, now, the first two colors are connected by lines to a third, also on the circle, we will find that by mixing all three in varying combinations and amounts we can produce the colors contained in the triangle formed by their connecting lines. Consequently, if this triangle, whatever its shape, contains the center of the circle, we can mix all spectral hues and many more colors than would otherwise be possible. And if, in addition, the colors which it connects are of extraordinary reflective strength and range, we will be able to mix all hues and considerably more colors than can be mixed with any other three colors. The three which satisfy this condition are the colors red-purple, yellow, and blue-green, primary in the graphic arts. As mentioned earlier, each of these colors reflects two primary lights. But despite this unique and appealing virtue, even these colors cannot be pigment primaries. The reasons are persuasive, at least to artists.

What is "Brown"?

The colors red-purple, yellow, and blue-green are unacceptable as pigment primaries because, yellow excepted, they are not pure hues. This means that they cannot produce the additional colors of high intensity and purity which artists want—the colors red, green, and blue. If, then, one of these colors must be added to yellow as a complement, it will assuredly be the color red. The coupling of yellow and red is inevitable, for yellow and red, when mixed, produce yellow-red, the warmest color, and an enormous, variegated cluster of colors called "brown." These are, of course, merely shades of the allied hues yellow, yellow-red, red, and possibly, red-purple. Nevertheless, to call them "brown" is to sing in the chorus of the literary elite, for poetry of the highest order is packed with similarly vague color references. Now the poet uses words for symbolic, metaphorical, and musical reasons. But when we see the adjective "brown" in other contexts as a term which intends to inform but clearly does not, we appreciate the practical importance of these colors and of the need to identify them exactly.

We do not, after all, have names for comparable hue groupings,

and the singular distribution of these hues in the visible spectrum is too clear and too relevant to be dismissed. It is clear that the hues red, yellow-red (orange), and yellow comprise about forty percent of the spectrum, and it is highly probable that they constitute a like percentage of the colors which we perceive in art and in life. In nature, certainly, the colors reproduced by mixing red and yellow, approximately half of which we call "brown," occur with overwhelming frequency. Who has not watched the autumn landscape erupt brilliantly and then burn itself out in its annual, spectral ritual? First a few cold snaps, and then rapid shifts of color as green leaves become yellow-green, yellow, yellow-red, red, and red-purple. These colors explode and glow erratically, and then, as their value and intensity differences dissolve, are silent. It is a cyclic spectacle as predictable and as irresistible as the tide, and through it all the dominance of "the browns" is unmistakable. And so if we accept the colors red and yellow as necessarily primary, we can see that the third color should be one which will produce all hues when mixed with them. Our options appear to be the pure colors green and blue, but the color circle indicates that we have none, for blue will do, and green will not.

It is not generally understood that the pigment primaries red, yellow, and blue are entirely discretionary, and that in this respect they are different from others. The physical primaries red, green, and blue for instance, are the *only three* types of light to which all colors are reducible. The graphic arts primaries red-purple, yellow, and blue-green are the *only three* pigments which absorb all light as each reflects two primary lights. And the psychological primaries red, yellow, green, and blue are the *only four* colors which by general consent are chromatically pure. On the other hand, the colors red, yellow, and blue are primary in the arts only because they are supported by a tradition which has rarely been examined. We should not, then, instantly reject the possibility that these colors are primary by default rather than by desire, or by chemistry rather than by consent, for it is a real possibility. And if true, we must conclude that artists, even to the present, have had to live with the serious limitations of their pigments as well as with their own shortcomings.

Pigment
Limitations
Certain green pigments and all red-purple ones, of which alizarin crimson is typical, are chemically suspect. Every pigment consists of a coloring agent in suspension in a binder, or vehicle. The oil

pigments used by artists, for instance, consist of colored particles dispersed and suspended in an oil or varnish binder. These particles can be organic, in which case they are of plant or animal origin, or inorganic, in which case they are probably natural minerals; in either case they can be synthetic. Many organic pigments are relatively unstable, or impermanent, especially those called "lakes," which are extracts of the root of the madder plant. These colors are so fugitive that even alizarin madder, a coal tar derivative produced synthetically, is not stable in the improved forms in which it is now available. And until recently, when pthalocyanine pigments replaced them, the intense green pigments which were available had to be approached suspiciously. The artist used these colors at his peril, for their base was usually copper arsenate (arsenic), and when they were mixed with virtually any other color, that mixture would in time become black. An artist could of course paint with intense red-purple and green pigments, but only if he were the kind who liked the uncertainty and finality of Russian roulette. Consequently, artists who assumed some responsibility for the permanence of their work faced a dilemma, and they resolved it by using these colors on special occasions and with discretion. But the colors red-purple and green, of high intensity, were not in any real sense available to them.

Primary Options

And so, working with what they have, not with what they wish they had, artists find themselves working with reds and yellows, earth colors of various kinds, and the cerulean, cobalt, and ultramarine blues. For reasons already mentioned, their aesthetic success must be attributed largely to ingenuity and the ability to work with limited means. But it is possibly true, as the manufacturers of pigments claim, that artists continue to restrict their palettes out of habit rather than necessity. If this means that artists can finally prescribe their primary colors without reservation, it means that they can work with at least five essential ones: red, yellow, green, blue, and purple. For if we arrange them symmetrically in a color circle according to hue, we will see that these five colors express working relationships of great interest. It is conceivable, though, that the preference of artists will gravitate to a more extensive and slightly different range of hues as expressed in a twelve-hued color circle based upon the three physical, or light primaries and their intermediate and secondary hues. This color circle, which consists of the hues red, red (ver-

milion), yellow-red, yellow, yellow-green, green, blue-green, blue-green (blue), blue, blue-purple, purple, and red-purple, reflects the presence in the spectrum of more red and yellow-red hues than others, and implies our instinctive predilection to use them. Unlike other color circles, it provides a schematic view of the most reflective hues and of the physical and graphic arts primaries. Like other circles, it identifies complementary hues and shows graphically that they are contractions of primary relationships.

Complementary Colors

Complementary colors are extremely different in hue, as everyone who works with color soon learns. But they are first of all any two colors which, when mixed in balanced amounts, produce a gray, or hueless, one. Red and blue-green are typical, and are said to be complementary because red light added to blue-green light equals white light, and because, inversely, red pigment added to blue-green pigment equals no light. This happens, when the proportions of the mixture are right, because in the first instance the primary lights—red, green and blue—have been fused, as in an additive mixture, and because in the second instance these same primary lights have been absorbed, as in a subtractive mixture. It is evident that complementary pigments, on being mixed, become hueless because they absorb three primary lights. This being so, we can produce the neutralizing complement of a red pigment by mixing it with any combination of pigments which reflects the remaining primary lights, blue and green. This condition will be satisfied if we add mixtures of blue and green, or even of blue-purple and yellow-green, provided they are mixed in the proportions which produce the color blue-green. It is certainly a paradox that pigments which reflect all light are required to produce a pigment which reflects none. But if this paradox is unresolvable, it is only because we have forgotten that a red pigment absorbs blue-green light while its own red light is absorbed, in turn, by a blue-green pigment. This is so regardless of the way in which each color is produced. Assuming, from this, that complementary pigments are totally subtractive, we rightly expect them, when mixed, to be black. We should not be surprised, however, to find that they are not. It must be apparent that pigments are not very intense, at best. This means that they reflect some light unselectively, and that this multicolored light

will continue to be reflected when they are mixed. In addition, pigments, like other surfaces, turn back minor amounts of light as diffused, specular reflection, so that the result of mixing complementary pigments is not to produce a black one but a gray one whose value is variable.

When we produce a gray by mixing several chromatic pigments, we know that these pigments reflect all hues in the relative amounts in which they occur in white light. We also know that we have mixed hues which are complementary, for the emotive case for complementary colors rests on the acceptance of white light as an absolute state, and on the tacit assumption that all colors aspire to it. Thus red, for instance, is psychologically incomplete without blue and green, the two hues which, added to it, will make it whole. Since this is a visual concept, not a verbal one, the twelve-hued color circle expresses it instantaneously. Lines which connect the physical primaries red, green, and blue-purple form an equilateral triangle, and when this triangle is turned on center, as if it were a dial, it will automatically select other triads which produce hueless pigment. In this way at least twelve primary triads and three times as many complementary pairs can be identified, since any two triads, mixed to produce the hue which lies exactly between them and then mixed with the remaining triad, will produce a gray. The color circle describes the circumstances which make this possible, and intimates, further, that by varying this formula imaginatively we can produce an astronomical number of low-key colors.

Low-Key Colors

These colors, appearing in nature, provide the subdued ambiences in which colors of high intensity and contrast are dramatic. This can be observed in the plumage of birds, for instance, and particularly in the plumage of certain males, where a few distinctive colors may be enhanced to the point of brilliance by the unobtrusive ones which surround them. Perhaps it is not so odd, then, that colors of this type should perform a similar function in works of art. There they are a means of expressing restraint and transition, especially in representational works, and it is significant that in art schools of an earlier era it was mandatory that students paint without black pigment, at least for a time. This dictum may have had several purposes, but we can be certain that its principal one was to acquaint students with the myriad of colors of low intensity which appear, as if magically,

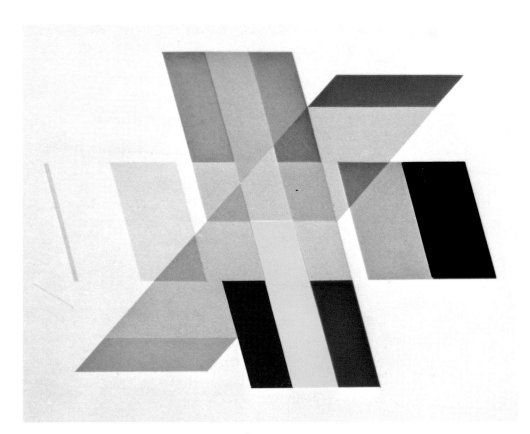

Plate 1

The Dimensions of Color

To know a color is to know its dimensions, and vice versa. In the case of a chromatic color these dimensions are hue, value, and intensity, each independently variable. A color can be red, yellow, green, blue, or purple, for instance, or any other hue, such as yellow-red, which can be produced by mixing them. At the same time, it can be light or dark, though it cannot be white or black, since these are independent colors. And it can be highly saturated or not, though it cannot exceed its natural, spectral intensity. This means that in every spectral color, hue, value, and intensity converge. So this illustration says, in effect, that every chromatic color is the sum of these attributes. It says that there is one which specifically names its hue, another which assigns a value to

it, and a third which reveals its saturation. (See page 8.)

These three qualities are the basis for the color-naming system developed by Albert Munsell, and models of his system have often been constructed by art students and others. These models, like the form developed by Munsell, are called "solids," and they are sometimes stunning in their insight, brevity, and execution. Constructed, perhaps, of clear plastic and wire and a few graded color samples, they demonstrate that every color is exclusively different from every other but related to it. The coordinated solid of Albert Munsell, after which they are patterned, is described on page 19.

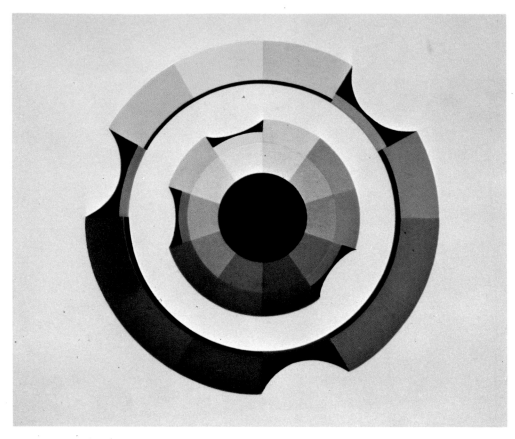

Plate 2

Primary Colors

The visible spectrum is a segment of the much larger electromagnetic spectrum which streaks through the earth's atmosphere. This segment, called light, consists of electromagnetic waves varying in length from 400 to 700 millimicrons. Since a millimicron is the millionth part of a meter, these wavelength distinctions are fine indeed. Nevertheless, the human eye and mind can distinguish as many as 180 of them. These perceived changes in the spectrum are its colors, and it has been demonstrated that three of them: red, green, and blue, when mixed in all combinations and amounts, will produce all colors except black. Appearing in the outer hue circle above are the three colors appropriately called the physical or light primaries (page 37).

But red, green, and blue are primary only in mixtures of light, and the usual interest of artists is in mixtures of pigments, which is a quite different matter. One set of pigment primaries, for instance, consists of the colors magenta, yellow, and cyan, which lie between the physical primaries. These colors, along with black, are used in graphic arts reproduction (page 41). At the rim of the smaller hue circle shown here are the traditional pigment primaries of the artist: red, yellow, and blue (page 36). Surprisingly, these colors are not distributed symmetrically in the spectrum. Nor are the psychological primaries, the so-called pure hues: red, yellow, green, and blue.

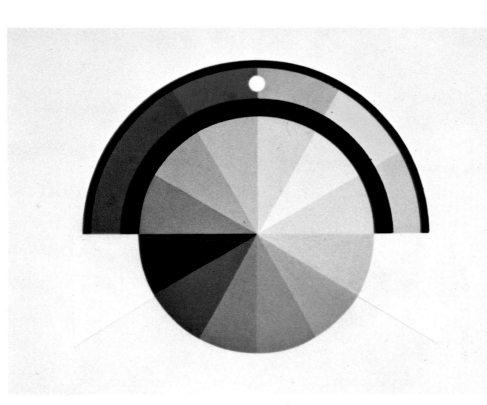

Plate 3

Color Temperature

In the visual arts, the temperature of a color is not a thermal fact but an emotional and associative response. Nevertheless, there is a necessary connection between fact and response, for experiences that are warm apparently cause others similar in color to look as if they are also warm. Associations of this kind are most clear and widely shared when they are both natural and universal. Sunlight, for instance, usually reaches us after its blue and violet rays have been deflected in the atmosphere, so that after a time its warmth and its characteristic colors are interchangeable. Surely, fire and blood have the same effect. And so despite the fact that the hottest thermal colors are blue and blue-white, as in the flame of an acetylene torch, the warmest color, emotionally, is a red (yellow-red) of high intensity, as indicated in the illustration.

Assuming that the coolest color should be complementary to this one, it is the color blue (blue-green). Assuming, further, that there are colors whose temperature is ambivalent, they are the colors green and purple. It is obvious that warm colors dominate in this scheme, as they certainly do in nature, and as they usually do in works of art. (See page 60.)

Warm colors are stimulating, of course. But these colors are spatially aggressive, too, for it seems that the red and blue-violet ends of the spectrum cannot be brought to sharp focus on the retina simultaneously, and that the compound lens of the eye, in bringing the warmest and coolest hues to focus, acts upon them as if they are the colors of near and distant objects. Thus it is that red and yellow-red colors are both ingratiating and assertive. (See page 67.)

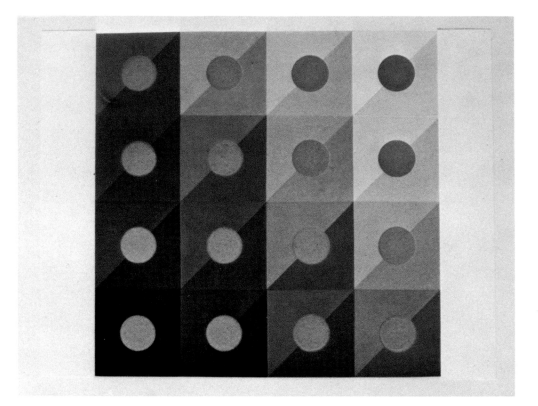

Plate 4

Simultaneous Contrast

The visual phenomenon called simultaneous contrast accelerates the contrast between adjacent colors. That is, it causes these colors to become increasingly different in the ways in which they are already different. Moreover, its influence is continuous and inescapable, so that we can predict confidently that when a light, intense yellow is placed next to a darker, less intense yellow-red, the first color will apparently become even lighter, slightly yellow-green, and more intense. Complementary colors, since their intensities increase simultaneously when they are brought together, seem to be the exception which confirms this rule. But complementary colors, already as different as possible in hue, can become more different from each other only by changing in value and increasing in intensity. This means

that an intense red, for instance, placed next to a less intense blue-green, will in a few moments become more intense and will cause the blue-green to do the same. (See page 87.)

This illustration has been contrived to reveal the multiple effects of simultaneous contrast. Inasmuch as the green discs shown here are in fact the same color, any perceptible change in their hue, value, or intensity must be accounted for in the way in which surrounding colors act upon them. And since these surrounding colors have been modified systematically, we can confirm many of our expectations. We certainly expect the discs to look darker and bluer when they lie against light yellow and yellow-red colors, and we expect them to look more intense when they lie against red-purple colors, regardless of other differences.

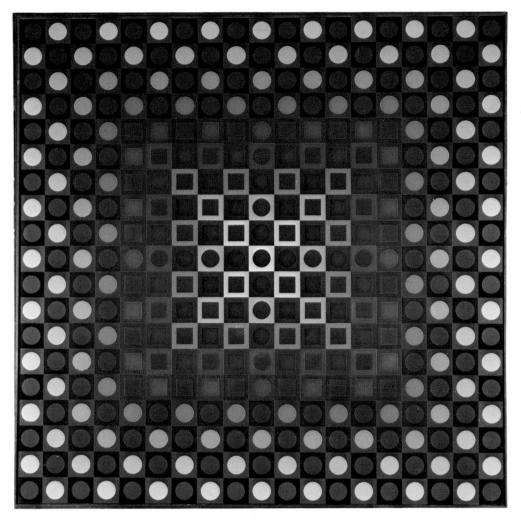

Plate 5

Victor de Vasarely, "Alom"

Courtesy the Museum of Art,
Carnegie Institute, Pittsburgh.
Gift of Howard Heinz Endowment.

Plate 6

Georges Seurat, "A Sunday Afternoon on the Island of La Grande Jatte"

Courtesy of the Art Institute of Chicago,
Helen Birch Bartlett Collection.

Plate 7

Benton Spruance, "Lazarus"

Courtesy of the Philadelphia Museum of Art.
Purchased: Harrison Fund.

Plate 8

Lamar Dodd, "The Cosmos: Gold and Maroon"

Courtesy of Louis Regenstein.

when we mix colors that are chromatically hostile. The restriction also made students uncomfortably aware of vaguely unnatural color relationships which are termed "muddy." These relationships proliferate without end, like indestructible weeds in a spectral garden. And they are not a matter of luck, as those who produce them would have us believe, but the predictable result of too much "value inversion." This inversion occurs when the colors yellow, yellow-red, and yellow-green are consistently darker than others; it will be described later as a separate phenomenon. Thus we have seen in the twelve-hued color circle that complementary colors are simple contractions of primary ones, and that by mixing these colors thoughtfully we can produce a profusion of unusual and unfamiliar ones.

The Ten-Hued Color Circle

For other practical purposes we turn now to a ten-hued color circle. It will consist of the five elemental hues: red, yellow, green, blue, and purple, and their complements: yellow-red, yellow-green, blue-green, blue-purple, and red-purple In this circle, yellow is the pivotal hue, and the lightest. It is opposed in the circle by blue-purple, the hue which is complementary to it, and the darkest. Arranged on successive diameters, clockwise from yellow, we will find the remaining complementary pairs: yellow-green and purple, green and red-purple, blue-green and red, and blue and yellow-red. These hues are chromatically distinctive and easily committed to visual memory, and since they are complementary, easily adjusted in hue, value, and intensity without the use of other pigments. Still, methods of mixing and modifying colors are a matter of technology, and technology must yield, finally, to an interest in the way in which colors add an emotional dimension to life and provide aesthetic satisfaction. Can we assume, for instance, that the color red is both physically *and* psychologically incomplete in the absence of the colors which complement it? Given a color of this hue and asked to choose another, there are indications that we will instinctively seek equilibrium and that we will find it in the contrast provided by the colors blue and green. This suggests, certainly, that in selecting colors, and especially in combining them, we search unceasingly for psychic stability, or unity, and that this unity can be defined and expressed. It is conceivable, too, that it can be expressed as regulated degrees of contrast among hues. This, in any case, is the probability on which "prescribed" color schemes are based.

These schemes contend that colors are necessarily compatible, or harmoniously related, if their hue contrast is rhythmic. Since the modular separation between adjacent hues in the ten-hued color circle is 36 degrees, any contrast represented there can be specified in degrees. This means that primary hues, if there are three, will be 120 degrees apart, and that the traditional "primary" color scheme of red, yellow, and blue actually consists of an indivisible hue, blue, and its complement, yellow-red, divided and appearing as yellow and red. A scheme of this type, in which a complement has been divided into two components 72 degrees apart, is called a split complement. A variation on this scheme is one in which both complementary hues are divided, and its consists, as one might expect, of four hues. These might be red and yellow, the components of yellow-red, and blue-purple and blue-green, the components of blue. Other schemes are constructed of sequential hues, as in the combination red, yellow-red, and yellow, in which two elemental hues are joined naturally by a transitional one. These schemes vary in detail, but their geometrical patterns are as constant as their message, which is that hues are harmonious when they are very different or not very different, and when this contrast is regulated, or rhythmic. Those who are persuaded by this message will avoid major color relationships in which hue contrast is in the 72 to 180 degree zone in the circular scale. Perhaps it is true that colors of equivocal hue contrast are now and forever incompatible. But to artists, guaranteed dissatisfaction, like guaranteed aesthetic satisfaction, is suspect. They know that hue relationships are restricted color relationships, and that no system of selecting hues can anticipate the baffling ways in which colors of unknown value and intensity, lying in areas of unknown size, shape, position, and direction, will act upon one another and upon those who see them.

Color Strategy

And so although the color circle is a systematic and natural order of hues, it is in no sense a clairvoyant means of reaching aesthetic decisions. Nevertheless, preset color schemes do imply that it has this peculiarly human capability to some extent, and this has caused many artists to ignore both the color circle and the somewhat dogmatic schemes which it has spawned. This, however, is as discriminating as throwing away the baby with the bath water. Moreover, it is unnecessary, for color schemes are not always rigidly prescribed, and in their more enlightened and

useful forms, are not prescribed at all. They are, instead, records of disciplined plans, completed or unfolding, and their purpose is to maintain creative continuity. They can do this because they may, on the one hand, be reviews of the behavior of color in a completed work of art, and on the other, be projections of the role which color will play in a new work. In this way, by documenting color strategies and effects and by formulating new ones, the color scheme is another vital liaison between yesterday's experience and today's hope.

Interestingly, the contention of prescribed color schemes is loosely supported in the study of works of art and in the ways in which artists proceed as they produce them. For having made a color commitment, artists are inclined, as perhaps everyone would be, to follow with hues which are similar or roughly complementary, and only then to seek an unconventional and expressive symmetry. This final symmetry is produced when the orchestrated energy of one area of color—which is the sum of its hue, value, intensity, shape, position, direction, and so on—is answered by the energy of another. Such relationships consititute structural dialogue, and they interlock and ricochet against the confines of the pictorial space, as it were, in every work of art in which color is a crucial element. This is why the color patterns in these works appear, usually, to be discontinuous and nonrhythmic. It is why they appear, in other words, to be so irrational, and why, in turn, the classic rigidity of the color circle is essential to an appreciation of them.

It is an honored truism, in art as in life, that one tends to see what he is looking for and to look for what he is prepared, for some special reason, to see. If this is so, the color circle embodies those "normal" expectations which prepare us to understand the unexpected and to recognize the extraordinary. Artists pursue elusive goals, as everyone knows, and since in this pursuit they naturally gravitate to the unexpected, where they hope, presumably, to discover the extraordinary, this preparation is important. It requires, however, a structural concept of the color circle, and a corresponding conviction that its structural characteristics are natural and inevitable. Perhaps this conviction cannot be confirmed absolutely, but it can be illustrated easily enough, if we assume that the color circle expresses only three expectations.

The color circle says that we normally expect the colors yellow, yellow-red, and yellow-green to be both light and intense, as we expect blue-purple, blue, and purple ones to be both dark and intense. For when a yellow or yellow-red color is dark and intense, or a blue-purple one is light and intense, we sense instantly that they are not normal tints and shades, and that they are therefore unusual. We expect to find, too, that most color configurations consist of indivisible hues, and of more red (yellow-red) and yellow hues than of other kinds, especially in areas of particular clarity and dominance. It is only for the purpose of convenient symmetry that these three hues represent twenty-five percent of the color circle, for they, in fact, comprise a considerably higher percentage of the spectral band. Since there are more distinguishable hues in this region of the spectrum than elsewhere, a work of art is unusual when its major contrasts are blue-green, blue, and blue-purple, and when darker, less intense red, yellow-red, and yellow colors are used to provide subtle contradictions. This happened in the "blue period" of Pablo Picasso. And finally, we expect hues, when they are not extremely different, to be sequential. We expect red, for instance, to be supported by red-purple and purple, on the one side, and by yellow-red and yellow on the other. The sequence purple, red, and yellow is equally rhythmic, but it is also unusual, for without auxiliary hues it will produce a work in which all intense colors of high value will be yellow. These expectations, and many others, are the principal justification of preset, or prescribed, color schemes, and so these schemes may have the dubious virtue of making the normal and ordinary more accessible. Moreover, these schemes are mainly concerned with variables of hue, and fail, of course, to take into account other variables, also structured into the color circle. One of these is an order of values.

The Natural Order of Values

The colors of the visible spectrum appear there in a fixed hue sequence, as we have seen. But they also appear in an equally constant value sequence, for when the indivisible hues of the color circle and their complements have been arranged at full saturation, it is apparent that the lightest of these is yellow and the darkest, blue-purple, and that between them, in descending, semi-circular sequences, are the hues yellow-red, red, red-purple, and purple, and the hues yellow-green, green, blue-green, and

blue. Consequently, while yellow-green is darker than yellow, it is at the same time lighter than green, of the same value as yellow-red, and lighter than red. This positive correlation between hue and value in the spectrum is called the natural order of values, and in the things we see, whether of nature or of man, it is an unrelenting expectation. We expect the infinite improvisations of the rising and setting sun, since they are no more than natural light refracted and dispersed by atmospheric interference, to be ordered in this way. And they are! It is somewhat surprising, however, to find that as a controlling principle the natural order of values extends to the earth's cover of leaves and grass and flowers, and to the distinctive coloration of birds and animals as well. This is not to say that yellow is without exception the lightest color in nature, nor that green, for instance, is always darker than yellow-green, for inversions of this order do occur in nature as refreshing and even startling dissonances.

For some time after the sun has dropped in the west, one can watch its lingering farewell in the eastern sky. This performance is usually less dramatic than the one which preceded it, but it is surely as varied, and in the opinion of many, more appealing. The supreme moment is when the sky, trapped behind immense, sweeping clouds, bursts through in rivulets and puddles of luminous pale-blue, and the sun's red-purple rays move restlessly from place to place among reddish clouds scarcely darker than the sky itself. The effect at this moment is overwhelming— elegant, yet, strangely romantic. It must be among the the most ingratiating in nature. Certainly it is among the most ingratiating in art, for it is characteristic, in every particular, of the color effects associated with the Venetian master, Tiepolo. This could be a historic coincidence, but it probably is not. For Tiepolo and the painters of his time shared a necessary vocational interest in all visual phenomena, and especially in aerial effects, and it is not difficult to believe that as an artist of sensibility he responded to this extraordinary effect, and simply seized it.

If Tiepolo had seen this kind of sunset, as no doubt he often did, he would have known that its colors were oddly related. He would have noticed that red was not the lightest of its hues, nor blue the darkest, as was usual both in nature and in the pigments which he and other artists used to represent it. In particular, he would have observed that the red color, though not especially dark, was darker than the others, and that the blue, though quite light, was

nevertheless darker than the red-purple. He would have recognized, finally, that the net effect of all this was to create a sky which was animated, grand, and theatrical. He would not have been so simplistic, however, as to attribute this effect to value-inversion alone, for one can produce many inversions of this type which are neither agreeable nor theatrical. It is possible, for instance, that the surprising absence of any light and intense colors from the red, yellow-red, and yellow end of the spectrum is merely one cause among many. But whatever the reasons for happy exceptions, they have an unhappy tendency to obscure the rule which makes them distinctive.

The Natural Order Inverted
The rule, in this case, is that in major relationships we expect colors to be naturally related. When the natural order of values, for instance, has been flagrantly disturbed, we too are involuntarily disturbed. And when this happens we must remind ourselves that the natural order of values is a set of timeless conditions, not a thinly-veiled aesthetic dictum. It is precisely because this order, and others, are natural and perpetual that we must try to understand them and to use them well before they use us badly. For although everyone knows that nature is not art, and that the purpose of art is not exclusively "to please," it is nevertheless true that what we have learned to expect in nature, perhaps through millions of years of tedious evolution, we confidently anticipate and demand in art and elsewhere. It may be, as some have suggested, that art provides the necessary counterpoint to these rigid expectations, and that it rightly asks us to acquire an enlightened and flexible vision. But it cannot expect us to reject the conditioning of the long and extremely special history of our senses, for even if it did, we would be unable, subconsciously, to cooperate. And so it is probable that the natural order of values, since it, too, is structured permanently into universal visual experience, affects our responses to color quite as much as the more glamorous and well-known distinction between warm and cool hues.

Warm Colors

Heat and Light
But before asking why it is that in works of art some colors are said to *look* warm, we should perhaps ask why it is that some colors *are* warm. Dark colors, for instance, since they always absorb a higher percentage of incident light, are warmer than

light ones. This means that a dark red surface is probably warmer than a light red one under the same illumination, and that the temperature of any reflected color is partly determined by its value. It is certainly not for aesthetic reasons that the clothing worn in tropical zones is white, or perhaps light blue, but for reasons of good sense, since these colors are efficient reflectors in natural light. And if we turn to the appearance of emitted rather than reflected light, we will see there a constant correlation between temperature and color. Colors, it seems, are reliable thermometers. This is strikingly illustrated when metals are brought to high temperatures, as in annealing. In this process the metal becomes luminous and red, and as its temperature rises it becomes successively yellow-red, yellow, yellow-green, blue, and finally, in its molten state, white. These unvarying color changes support our belief that heat and light, and therefore color, are interchangeable energies. If light can be absorbed as heat, so that it is nonvisible, there is every reason to think that heat can be released as light and thus made visible. It can be, of course. And if we know that lightwaves vary in frequency as well as in length, we can easily understand why this happens.

All electromagnetic rays move through space at the same speed, which, give or take a fraction, is 186,000 miles per second. We are told that they move as waves, and that they are identical from crest to trough, or in amplitude, but variable from crest to crest, or in length. Of those waves which are visible, the ones which excite the hue sensation red are longest, and those which excite the sensation blue-violet, shortest. All waves moving at the same speed, it is plain that more blue-violet waves than red ones will travel a given distance in a given time. This is why, on being heated, metal glows first as a concentration of red waves. But as its electromagnetic activity increases, it begins to emit waves of increasingly higher frequency, and simultaneously to change in color. For when yellow, and then green, and then blue, and then violet waves have been added to the red ones, the cumulative effect is white light. This is logical and credible. But the authority of logic does not extend to art, and what one wants to know is whether this particular equation between temperature and color has macrocosmic meaning—that is, whether it is an isolated instance or a model of thermal-visual experience which occurs on a much wider scale in nature and in life. If the latter, as it seems to be, it says that red is a warm color, that yellow-red, yellow, and blue-violet are warmer still, and that white is hot.

A Natural Temperature Scale	Fire is not a recent discovery, and in the remote lives of our ancestors when eating, keeping warm, and protecting oneself against enemies were full-time occupations, fire was a common sensory experience, vital to survival. Less common now perhaps, it is more an experience of man than of everyman. But the still vital sun continues to shine, and if a preoccupation with the descending and disappearing "fire" in the sky did not encourage us to ignore the morning sun, we would see immediately that it often rises in a brilliant ambience which is yellow, blue, and purple, and that it is itself white. It is also a "hotter" sun, and the color sequence around it suggests that a natural color-temperature scale should consist of the hues red, yellow-red, yellow, blue, blue-purple, purple, and white, rising in value and increasing in intensity and luminosity in the same order. One is much more convinced that this is a true temperature relationship than that any of these hues, taken singly, is warm or cool.

Visual and Tactile Association	Electronic sensors which measure the heat reflected by surfaces report that, all things being equal, red and yellow-red surfaces are warmer than, say, blue and green ones. But when one considers that sensors are supra-extensions of our natural capabilities, and that all things, such as the texture of a surface and the value and intensity of its color, are rarely equal, it seems highly unlikely that we learn through normal contacts with surfaces that red ones are warmer than others. Still, we acknowledge the existence of warm and cool hues even though we know that temperature and color are different kinds of sensation and are not interchangeable. We do this, apparently, because we have learned to reconcile the different and even conflicting reports of our senses. It is inevitable that we shall learn, just as our ancestors and other creatures have, that seeing a flame and touching it are different experiences, and that the one quickly imposes itself upon the other and is in time equatable with it. This leads, of course, to the sympathetic argument that at a point early in our lives, when we first perceived that the sun is often red and that we are always warmed by it, the sun became (subjectively) both red and warm. One is easily persuaded, then, that after endless confirmation, we began to equate the hue red with the general tactile sensation warm, and to make them emotionally and symbolically inseparable. One makes this equation regularly in the arts, where experience is multi-sensual, and perhaps warm and cool colors have acquired their connotations in this way. In any event, it is generally agreed that nonvisual attributes, like temperature, are visually expressible, and that the reason is a rich blend of association and feeling.

It is usual for a visual image to stand for past experiences with which it is emotionally associated. On seeing an umbrella, for instance, one may relive a leisurely walk in a cool rain or perhaps a languid afternoon on the beach. Since colors tap veins of sensual memory in much the same way, we expect the hues red, yellow-red, and yellow, if they are warm, to revive and equate with experiences which are inherently and constantly warm. They do equate with the most obvious of these, for fire is red and yellow-red, as is blood; and the sun, blazing through the atmosphere, is yellow, yellow-red, and finally, red, as it comes to rest for a long moment on the horizon. Moreover, in our ancestral recollections these hues are synonymous with the hunt and with the barbaric spirit of ceremonial ritual. That they should be associated in our present experience with the vigorous, the festive, and the passionate, is consistent and fitting. And when to these associations is added the fact that red is the most aggressive hue, that yellow is the most luminous, and that both are indivisible, our predilection for them in works of art is understandable. It is clear that in our lives, and in the life of the race, these hues characterize experiences which are especially human and universal.

Cool Colors

Warm hues imply the existence of cool ones. Since warm hues are identified with aggressive, vital, even violent experiences, we would expect the hues blue-green, blue, and blue-purple to induce in us responses of a contrasting nature. Thus cool hues will be identified with the intellectual, the tranquil, and the dispirited, and by juxtaposing these hues in the color circle with warm ones we can produce a dualistic system of opposing hues and moods. Except in clinical situations, however, a single hue never appears in a one-to-one relationship to the mental and emotional state which it might evoke. And so while we are probably pacified by the hue blue, just as we are certainly stirred by the hue red, we rarely if ever find ourselves in an environment which establishes this beyond doubt. An environment of any constant hue will in fact produce mental and retinal fatigue if we remain in it for prolonged periods. Moreover, color is a surface quality and surfaces are "shaped," and so it would not be difficult to produce a work of art in which baroque blue shapes were more animated and exciting than less varied red ones. Despite these doubts, action requires reaction, and the notion that warm hues require

cool ones is intuitively appealing, for it is yet another tool with which to think about color.

Neutral Hues The separation of hues into warm and cool groups is an emotional and associative consensus, not a separation suggested by the spectrum or the color circle. Nevertheless, like so many conclusions reached by collective intuition and sense, it is more rational than seems at first to be the case. For if one is persuaded that warm and cool hues affect us in contrasting ways and represent a valid distinction among colors, he will find that this conviction is supported in the classic color circle. But before looking at the way in which warm and cool hues are ordered there, we should consider for a moment the two hues which by general consent are neutral. These are the elemental hues green and purple, in which neither a warm hue-strain (a red or a yellow) nor a cool hue-strain (a blue) is present. They might more accurately be called ambivalent, since the slightest alteration of hue will cause them to look either warm or cool. Also, since warm hues, especially red, appear to advance in space as cool ones apparently recede, these neutral hues produce less tension on being seen and vacillate less in space. The ease with which they migrate, to become warm or cool, and their spatial stability, account for their radiance in shifting illumination and their visual comfort.

We may infer from the neutrality of the hues green and purple, that the warmest and coolest hues will be equidistant from them in the color circle (see Plate 3). And this is the case, for the hues which strike a balance between them are yellow-red and blue. Supporting yellow-red are the hues yellow-green, yellow, red, and red-purple, on the one side, while supporting blue are the hues blue-green and blue-purple, on the other. Of these eight hues, five contain a hue-strain which is yellow or red, and are warm, and three contain a hue-strain which is blue, and are cool. This ratio of warm to cool hues corresponds, generally, to the virtually universal dominance of warm hues in works of art. But however convenient the separation of hues into psychologically distinct groups, it is futile if it does not clarify color relationships. It is as important to know that yellow-red is *warmer* than red-purple, for instance, as it is to know that red is warm and blue is cool.

Relative The emotional and associative temperature of a color is, after all,
Temperature another of its dimensions, and artists habitually and frequently

speak of cool yellows and warm blues. For many, this is a puzzling contradiction. But in the context of the color circle the confusion which this creates is more apparent than real, for if we accept the aesthetic principle that color interaction is never anything but relational, it must evaporate. Yellow is a warm hue, to be sure, but it is not the warmest, and in the present frame of reference it is cooler than yellow-red. Yellow-green, which is also a warm hue, is nevertheless cooler than yellow, and green, which with respect to the entire color circle has no bias, is even cooler. Moreover, these hues, like all others, are subject to the direct influence of the ambience, or setting, in which they are seen. If red-purple is a pivotal and central hue in an arrangement, it may shift uneasily, first to the red and then to the purple, when changes occur in the colors adjacent to and surrounding it. Such shifts of hue, and of intensity and value as well, are said to be induced, which is to say that they are produced involuntarily by retinal fatigue and recovery. This brings us to the large question of simultaneous contrast, but since it is an optical and physiological phenomenon, an explanation of it must be deferred until the mechanism of vision has been described.

Color Contrast

CHAPTER TWO

It has been said that eighty percent of the information which we assimilate through the senses, and on which we depend for survival and the funding of knowledge, is visual. This is probably correct, for the location, mobility, and hardy resilience of the human eye attest to its extreme natural importance. But despite its critical nature, or perhaps because of it, the eye is anatomically simple, and if we examine it disinterestedly we must see that it is first of all a dark chamber which admits and collects light, and reacts to its presence. For this reason, the eye is often compared with the camera, and while it is true that they are similar in many structural ways, it is also true that the capabilities of the camera are not those of the eye.

We all know that the camera can be focused precisely for indefinite periods of time and on subjects which are too close, too distant, or too small to be appreciated by the eye. We know, too, that it can be made to arrest movement, as in stroboscopic photography, to "see" in extremely low illumination, and to react to the invisible, as in infrared and x-ray photography. It is precisely because the camera makes unusual and otherwise inaccessible information available that we are inclined to think of it as a highly specialized eye. This is an understandable mistake, of course, but a mechanism can never be an organism, and the one can neither equal nor improve upon the essential purposes of the other. Transplanting a heart, for instance, is certainly different from implanting a pump, as the world's finest surgeons are even now discovering to their dismay. Still, if it is handled with discretion, the analogy between the camera and the eye can be instructive. Discretion, in this instance, simply means recognizing that the camera is an instrument of photography, not an instrument of vision, and that the camera and the eye are comparable because both report optical patterns, the one to a photosensitive sheet of celluloid, called film, and the other to the retina.

Characteristics of the Camera

In every sophisticated camera there are three indispensable elements. Two of these act upon light by affecting its flow and quantity, and the third is acted upon. Always there is a shutter, which admits specific amounts of light through an aperture in the front wall of the camera and into its dark interior; a lens, or lenticular system, which collects and refracts this light; and a photosensitive plane, or film, on which it can be recorded as a visual pattern. These three elements are so arranged that when a ray of light passes through the center of the lens it will also pass perpendicularly through the center of the aperture of the shutter and will strike and activate the film. Even the amateur knows that each of these elements is variable—that shutters may be manual, automatic, or tachistoscopic, for instance—and that lenses may differ in form and focal length. And if to such variables as these we add the fact that films react to light with varying degrees of sensitivity, it is apparent that cameras can vary greatly according to their purposes. Because the human eye is structured of the same three elements arranged in much the same way, it can with reason be compared with the camera. But in making this com-

parison we must remember that although the eye is a photomechanism and therefore undeniably like the camera, the camera is not much like the eye. For in the last analysis, the eye is a living, restive, tireless, data-collecting outpost of the central nervous system, not a precise and rigid optical mechanism.

Efficiency and Inefficiency Furthermore, the human eye is notorious for its optical inefficiency. If its purposes were those of the camera it would never get off the production line, for it is very often astigmatic, myopic, or hyperopic, and unable to resolve chromatic and spherical aberration under the best of circumstances. The cornea is often imperfectly formed, the eyeball itself is often too elongated or compressed for the formation of sharp images on the retina, and the action of the lens invariably brings lightwaves (which are short or long) to focus in front of or beyond the retina rather than on it. Moreover, because the eye is organic, its efficiency can be affected by a variety of psychological and physiological factors; and over the span of a lifetime, it must change somewhat. Fortunately, however, the essential function of the eye in biological survival and in the conduct of human affairs is to gather information attentively, and when necessary, selectively, and it need not be optically flawless and specialized in order to perform this function exceedingly well. Indeed it is because the eye focuses continually and involuntarily for short periods of time, not statically for indefinite periods of time, because it brings to focus subjects which are ordinarily relevant, not those which are microscopic or otherwise extravisual, and because it permits us to detect, synthesize, and summarize movement, not to arrest and analyze it, that the human eye is so effectual. It scans constantly, as the ear hears constantly, and in the process makes urgently needed information available to the mind, which must discriminate quickly and well. Consistent with this role, the eye is tough, highly adaptable, and neurologically complex.

Anatomical Features of the Eye In physical structure, the eye is a hollow sphere filled with a gelatinous fluid. Its casement consists of three thin layers of tissue, and on its anterior face is a pigmented disc, the iris. The center of the iris is an adaptable circular aperture, the pupil. In front of the iris and fitted to it is a dome-like lens, the cornea, while suspended behind it is a double-convex, or compound lens. The anterior chamber, which is the space between the cornea and the iris, contains the aqueous fluid; the much larger interior chamber, which causes the eye to retain its generally spherical

shape, contains the vitreous fluid. The lining of this interior chamber is the retina, an unbelievably complicated fabric of minute sensory receptors. These are, in fact, extensions of the optic nerve, much as the roots of trees are elaborate extensions of their trunks. But to describe the eye physically is not to say very much. For the events which occur in the eye are inseparable from it. Moreover, these events occur only in the presence of vitalizing light. Light is to the eye what air is to the lungs or blood is to the heart, and without it the eye is a static and senseless object. Like the camera, the eye must act upon light and react to it, and any description of the eye which does not allude to this fact has seriously missed the mark.

Light enters the eye through the transparent cornea, where as much as sixty percent of its total refraction may take place. It then penetrates the aqueous fluid and continues through the pupillary opening of the iris. The iris is a contractile diaphragm controlled by ciliary muscles which "set" the pupil so that at any given moment an optimum amount of light is admitted to the interior chamber of the eye. The reaction of the iris indicates, certainly, that intense and prolonged exposure to light threatens the well-being of the retina, for although the pupil always dilates slowly, it "stops down" instantaneously when necessary. That is why, having stepped into the light, we can see clearly after a momentary shock, whereas we are sightless for some time after we have stepped into darkness.

How the Eye Acts upon Light

Having passed into the interior chamber of the eye, beyond the iris, light enters the compound lens and is refracted once more. The compound lens is a crystalline capsule, supported and controlled by suspensory ligaments and muscles which are attached to the wall of the eye. It focuses by an accommodation whereby it becomes flat as its suspensory ligaments become taut, and convex as they relax. After this final refraction, light strikes through the vitreous and converges on the retina, at which point, having journeyed in a fraction of a second through the cornea, the iris, the lens, and the aqueous and vitreous bodies, it activates photoreceptors in the retina. These receptors react by converting light into neural energy, presumably by an electrochemical process, and discharging it into the sensory nervous system as impulses which will be perceived as color. And of course, when the nerve fibers of the retina have been activated, vision is no longer a structural matter but also a physiological and psychological one.

Atmospheric Perspective

The journey of light through the eye to the retina is not without incident. The prompt response of the iris to protective messages from the retina has already been mentioned. But tension in the musculature of the lens as it attempts to cope with unresolvable optical problems affects us more seriously and more often, and in one instance at least, affects our perception of space. There is wide agreement that intense red and yellow-red hues are spatially aggressive, and that their opposites in the color circle, blue and blue-green, are passive, or recessive. This phenomenon can be explained in part by association and conditioning, for natural surfaces are invariably bluer, less intense, and lighter when they are more distant. Atmospheric perspective, which is the study of natural light and the way in which our perception of near and distant objects is influenced by it, confirms this hue-drift again and again. It is most apparent on clear days when we are looking away from the sun, for then the blue end of the spectrum, deflected downward by particles in the atmosphere, saturates distant surfaces and at the same time erects a wall of diffused, white light between them and ourselves. It is conceivable, of course, that these colors look recessive for reasons which are more emotional and subjective, since large bodies of water, as they roll to the horizon line and beyond, are most often blue, blue-green, and maybe blue-purple, and since the sky, if it may be said to have *a* hue, is blue. Now that we can see our own shadows on the surface of the moon, as it were, the sky is more than ever a symbol of infinite space, experience, and wisdom. But even if association accounts for the recessive tendency of blue and blue-green hues, it cannot convincingly account for the spatial aggressiveness of others. A plausible explanation does lie, however, in the effect of chromatic aberration on accommodation in the lens.

Why Warm Colors Advance

The lens normally focuses yellow lightwaves right on the retina, red and yellow-red ones beyond it, as in farsightedness, and blue and blue-purple ones in front of it, as in nearsightedness. This is chromatic aberration, and it means that when the lens does bring red and yellow-red lightwaves to an effective focus on the retina, it is acting upon them as though they had been reflected from surfaces which are nearer than is actually the case. If we add the fact that in accommodating to long lightwaves and to near objects the action of the lens is apparently the same, an inference is inescapable. We know, first of all, that the ability to see clearly at close range is acquired, since in the first days of life, as in the last,

we are farsighted. We know, too, that in the interim the lens works unceasingly as it adjusts and readjusts its shape and curvature so that the light from near objects can be effectively focused. We may infer, then, since the lens also brings long lightwaves to focus in the same way and at the same time, that this has the subtle but certain effect of instructing the mind that these lightwaves have really been reflected from objects which are near—or at any rate, nearer. The lens acts upon lightwaves, not upon colors, and to the mind which must process sensory information in a hurry, the message is no doubt unclear. Naturally, the effect of such regular misunderstanding it not to cause near objects to look red but to assign new spatial positions to red and yellow-red surfaces. As a result, such colors as red and blue, when seen together at high intensity, show a curious separateness. This spatial quality has been thoroughly exploited by many contemporary artists, by some to the point of obsession. They recognize that it is an exceptional and constant distinction among colors, and that it is experienced first as involuntary tension.

Complementary Colors and Optical Stress

The spatial tension which we feel when we see red and blue hues simultaneously is primarily a symptom of optical stress, and this stress may easily be compounded by substituting blue-green for blue, since red and blue-green are complementary and therefore divergent. The intensity of each of these colors is apparently increased by the mere presence of the other, and this contrast may be so great in certain instances that the edge between the two colors, or their contiguous edge, is uncomfortably blurred. When it is, we know that to the chromatic imperfections of the lens we have added a pinch of simultaneous contrast. Still, the lens of the eye is a wondrous instrument, especially from a teleological point of view. It is of a slightly yellow tint, for instance, and becomes increasingly tinted, so that late in life much of the blue end of the spectrum, always difficult to bring to focus on the retina, is absorbed. But with all its refinements, the lens is to the retina as a sundial is to the finest jewelled watch. The retina is extravagantly intricate, and the precise way in which it reconstitutes light by converting it into neural impulses has not yielded to the most intensive research.

The Structure and Function of the Retina

The retina forms very early in the human embryo, evidently as a protrusion of the forebrain, and on full development is a visible

and important tributary of the central nervous system. As most of us know from personal experience, physicians can detect serious systemic disturbances by observing the retina directly through the pupillary opening of the iris. They can observe the retina because it is the innermost of three layers which comprise the wall of the vitreous, or interior chamber of the eye. The retina itself is composed of ten microscopic, differentiated layers, all transparent except one. This exceptional one is a dark, pigmented layer, called the epithelium, by which the retina attaches to the choroid or middle layer of the vitreous wall. However, it is the second retinal layer, lying next to the epithelium, which is critical in color vision. This layer is an astonishingly dense field of two somewhat similar types of nerve fibers, called rods and cones, which impinge upon the epithelium and are perpendicular to it. They are sensory receptors, and at their points of perpendicular contact with the epithelium each contains a substance, *visual purple,* which absorbs light and at the same time reacts to it. On being stimulated by light, the rods and cones encode their reactions as electrochemical impulses. These are then transmitted through the optic nerve and through more remote visual pathways to cortical centers in the brain, where they are decoded.

Retinal Function The precise way in which rods and cones initiate color sensation is still a matter of some speculation. This is understandable, for these two receptor types exist in the retina in overwhelming profusion. In the whole of the retina there are at least 137 million receptors, of which about 7 million are cones. This is an awesome total, as well as an odd ratio. One should not be mislead, however, by the numerical advantage of the rods, for the geographical distribution of receptors in the retina clearly points to the sensory superiority of the cones. Cones are present everywhere in the retina, but are concentrated in a small, central region called the macula, or yellow spot, and particularly in the center of the macula in a region called the central fovea, where they are incredibly compressed. The central fovea is a shallow, saucer-like pit in the retinal wall, lying at the point of intersection of the line of sight and the retina. It is at this point that light from the center of the visual field is brought to sharp focus, and so the usual topographic subdivisions of the retina are concentric about it. These would be the central fovea, which subtends an angle of about $70'$ at the nodal point of the lens, the macula, which subtends an angle of about $12'$ at the same point, and the parafovea, which extends outward from the perimeter of the macula. This means that in an eye which is 1 inch in diameter,

normal for an adult, the entire foveal region is roughly .1 inch in diameter, and the region of greatest receptor population, the central fovea, only about .01 inch. And its meaning is not trivial, since only images formed on the foveal regions of the retina can be seen in unrestricted color, and only those formed on the most central region, the region of the central fovea, can also be seen with acuity.

The Visual Field

The visual field has been carefully plotted on the retina, and is much larger than the foveal region. This is not a surprise, certainly. But it is not circular, either, as the principal subdivisions of the retina are, and this is rather surprising. We find, in fact, that the visual field is a horizontal oval, and that it subtends angles of 90° outward, 60° inward, 50° upward, and 70° downward. From this description, one can see that it is distinctly lateral in shape, and this suggests that we probably see and perceive images along lateral axes with a maximum of ease, continuity, and pursuit. This lateral inclination may even explain why vertical movements, which enter and leave the field of vision more quickly, are also more arresting and dynamic than horizontal ones. But however that may be, the visual field contains yet another surprise.

Hue Sensitivity in the Retina

It seems that images formed on the most peripheral regions of the visual field are not perceived in chromatic, or three-dimensional colors, and the sensitivity of the visual field to color is both gradual and selective. When the psychological primaries, red, yellow, green, and blue, are introduced into the field of vision slowly, and perhaps as objects, blue is the first to be perceived as hued. It is followed, after a momentary delay, by yellow, red, and green, and we are told that if blue-purple were introduced under the same circumstances it would be the last to become hued. This means that total color vision is theoretically a myth, since we continuously see images in the periphery of our vision but do not perceive their hues. Most of us, who see the world in uninterrupted, chromatic color, find this difficult to accept. But we do not give our attention to images which are in the periphery of our vision, preferring, sensibly, to turn toward them when they interest us. And we must remember, too, that the eye oscillates

involuntarily as it moves voluntarily. These movements cause the visual field to shift restlessly, and this shifting, in turn, causes the images on its perimeter to appear to be alternately hued and hueless.

Photopic and Scotopic Vision

Photopic Vision

As one might expect, the perimeters of this restricted color field are roughly concentric with that of the field of vision as a whole. The blue color field is largest, and the blue-purple, or violet one, which is also fully chromatic, is smallest. The latter is subtended by angles of 70° outward, instead of 90°, and 40° inward, instead of 60°. This greatly reduced region of the retina is important because it is the field of totally effective color vision. But it is significant because it corresponds with that region of the retina which is clearly mediated by cones, in what is called photopic, or daylight vision. This tells us that cones are activated in moderate-to-intense illumination, and that their ultimate function is to make acute color vision possible. We expect them, then, to be concentrated, and even impacted, in the region of the central fovea. And they are.

Scotopic Vision

Rods, on the other hand, predominate in the parafoveal, or extrafoveal regions of the retina, where their ratio to cones may be as high as 30 to 1. This ratio is reduced at the macula, reversed at the perimeter of the central fovea, and wiped out in the central fovea, where there are evidently no rods. The net effect is a distribution of rods and cones which is both overlapping and inverse, for as the cones, which are dominant in the central area of the retina, diminish in number outward, the rods, which are dominant in the periphery, diminish in number inward. We may certainly assume, from their location, that the rods are activated by light which originates somewhere in the periphery of the field of vision. But the rods are particularly sensitive to light of low-to-minimal intensity, and apparently their primary role in vision is to mediate what is called scotopic, or twilight vision. Since such vision is hueless, as everyone knows from experience, there is at some point in diminishing illumination a threshold at which rods are stimulated and cones are retired. This is the point at which acute, chromatic, centralized vision is replaced by vision which is indistinct, achromatic, and decentralized. This threshold is alluded to in the Purkinje phenomenon.

71

The Bohemian physiologist Purkinje demonstrated that in diminishing illumination colors retire or become hueless in a natural order, and that this is an order in which hues of long wavelength retire first. This means that in gradually diminishing light the color red will become less intense before others are affected, that it will become hueless, and finally, invisible, as the cones of the retina are retired, and that it will be followed by yellow-red, yellow, green, blue, and blue-purple, in that sequence. He demonstrated, at the same time, that if the illumination is again increased, these same hues and intensities will be restored, but in reverse order, the blue end of the spectrum leading the way. This performance can be seen at dawn and at dusk as natural forms acquire their coloration and just as mystically abandon it. The Purkinje phenomenon emphasizes the sensitivity of the rods and cones to lightwaves of high and low frequency, and in the process, explains why the blazing autumn landscape is so quickly and strangely changed at twilight, why the early morning light on the river is so cool and silvery, and why the night itself is so decidedly blue and violet. Like nearly all visual phenomena, this one has practical as well as subjective implications. Certainly those who design highway signs ignore these implications at their peril. And in the first World War, after several of our hospital ships had been mistakenly attacked by our own planes, we finally learned that the practice of identifying such ships by painting them white and marking them with red crosses was as misguided as it was well-intended. We learned, if somewhat belatedly, that white and red are not the most visible colors under all circumstances, and that painting these ships *black*, though symbolically disturbing, would be more humane. Similar examples could be cited. But if there are other useful ramifications of the Purkinje phenomenon, they have yet to be explored. With the emergence of luminal art which specifically studies the nature of reflected, emitted, and transmitted light, there is little doubt that they will be.

The Purkinje phenomenon has inviting implications for the arts, but there are other aspects of the interplay between photopic and scotopic vision which are equally interesting. One of these is the fact that although we see with acuity and see chromatically in the light, we enjoy a much enlarged field of vision in the dark. Or put another way, although we see more clearly in daylight, we see

more expansively at night. There are insistent overtones, here, of biological evolution and survival, for we are also remarkably sensitive to the slightest movement, especially in the periphery of the field of vision. But we are not now nocturnal, and these perceptual traits merely point to the complexity of the whole question of chromatic stimulation in the retina and beyond. They force us to ask, eventually, how only two discernible types of visual receptors can mediate as many as 160 hue distinctions and a stunning myriad of variations in value and intensity. Reputable hypotheses are not wanting.

Color Vision and Theory

Structured into theories, these hypotheses hope to explain the way in which light is encoded and then perceived as color. By implication, they are concerned with the physical, physiological, and subjective phases of color vision; or with the structure of the eye, the behavior of the visual-neural system, and the processes of sensing, perceiving, and reacting. Of course, they are not an inclusive theory, and it may be that such a theory of color vision is not a realistic possibility. It would in any case be incompatible and inconsistent with the usual methods of investigation, which effectively separate color experience from its presumed causes. This dichotomy is nowhere more clear than in the failure of interested artists to assimilate and relate to findings in this field, and it suggests that in the sense in which color is a summation in perception, nearly all theories of color vision, lost in the forest, are aimlessly chopping down trees. To be sure, any theory has value if it gives direction, dimension, and focus to attacks on the problem to which it addresses itself. But to artists, the validity of a theory of color vision must be measured by the degree to which it is consonant with visual phenomena, and past and current theories do not convincingly meet this test. That, possibly, is why they are still theories. And that is why, in sifting through research material on color vision, most of it spin-off from studies of retinal structure and behavior, one finally wonders where investigators think the "color" in color vision really lies.

Color and Consciousness
Specific color, as we know, is not a fixed quality in objects but a variable quality of objects. A red ball, since its color can and will change, is simply a sphere which happens at the moment to look red. But if this ephemeral attribute *red* is not in the ball, is it in

the light reflected from the ball? In the retina? In the channels of the nervous system through which stimulation is conveyed to appropriate centers in the brain? Or in the interpreting psyche? It can be be said to reside in all of them, but in the visual arts it is natural and correct to assume that color is greater, somehow, than the sum of its causes, and is therefore a qualitative entity in consciousness. And so it is conceivable to artists that our understanding of color vision is advancing slowly because we are determined not only to study its physical and physiological bases, but also to examine them in clinical isolation, as if they can be explained and then related to phenomenal experience. This is no doubt possible, and difficult. But it is possible, too, that investigators in this field are addicted to turning their big guns on the wrong targets, and that an equally determined study of color phenomena would quickly evoke new insights.

The Land Theory

The experiments of Edwin H. Land illustrate this point, and if they do not constitute a coherent theory of color vision, they certainly raise formidable doubts about the consistency and credibility of traditional ones. The sense of Land's conclusions is that in order to see the world chromatically we need less stimuli than we normally receive, and considerably less than was formerly thought necessary. For he has found that when two beams of yellow light, one representing the longest wavelengths and the other representing the shortest, are projected and superimposed, they can stimulate full-color perception. There are conditions, of course. These are that a pair of black and white transparencies of the subject intercept these beams, and that the range of tones in one transparency be lighter or darker than in the other. Such transparencies can be produced by photographing the subject through a red filter and then through a complementary blue-green one, since these filters transmit light of contrasting wavelength. When the two kinds of yellow light are projected through transparencies which modify their intensities, the retina instantaneously reports that the subject is multicolored. All colors in the subject are reported when the long-wave light is projected through the long-wave (red) transparency, but the subject is nevertheless colored when the pairs are reversed. It is apparent, then, that the varying lengths of electromagnetic waves which we call light are not in themselves the cause of color differentiation

and discrimination, and that Land's hypothesis, which is that color in natural images arises from the interplay of longer and shorter wavelengths over the entire visual field, may in time lead to a new concept of color vision.

In the simplest of demonstrations, the phenomenon on which Land has based his assumptions about color vision can be reproduced by anyone who has a modest amount of photographic skill and equipment. First, the light from two ordinary projectors must be superimposed, and a red filter attached to the lens of either so that the projected light is red. For then, when a black and white, long-wave transparency of subject X is inserted into the projector to which the filter has been attached, and a black and white, short-wave transparency is inserted into the other, the subject will appear in full color. Inserting these two transparencies—the first made through a red filter (to produce a transparency of long wavelengths), and the second made in natural light (to produce a transparency which contains short wavelengths, among others), does not change the light reflected from the subject. It merely emphasizes the relative difference between beams of longer and shorter wavelength from point to point in the visual field.

All this adds up to the postulate that the colors in natural images are determined by the relative balance of long and short wavelengths emanating from them. As Land stated in "Experiments in Color Vision" (*Scientific American*, May 1959): "What happens in the real world, where the eyes receive a continuous band of wavelengths? We are speculating about the possibility that these wavelengths register on the retina as a large number of individual color-separation 'photographs', far more than the three that Maxwell thought necessary and far more than the two that we have shown can do so well. The eye-brain computer establishes a fulcrum wavelength; then it averages together all the photographs on the long side of the fulcrum and all those on the short side. The two averaged pictures are compared, as real photographic images are compared in accordance with our coordinate system."

Land's proposal is modern in form and expression. It is especially so because it follows a succession of brilliant speculations on the nature of color vision, all formulated in the last century and all peculiarly retinal. Three of these are representative, and certainly

renowned. They are the Duplicity theory, the Hering theory of opponent colors, and the trichromatic theory of Young and Helmholtz. We will look at teach of these in turn.

The Duplicity Theory

A Theory of
Dual Retinas

The Duplicity theory is the authority for earlier statements that scotopic vision, which is hueless, is mediated by retinal rods and that photopic vision is mediated by retinal cones. It speculates on the possibility that rods and cones are separate mechanisms whose functions are different but complementary, and leans heavily on the unusual distribution of these receptors in the retina. There is, certainly, an impressive correspondence between the region of chromatic vision in the retina and the distribution and concentration of cones. In dark-adaption, which is the process by which the retina adjusts to the visual requirements of low illumination, vision becomes hueless, diffuse, and peripheral. Inasmuch as the rods are dominant in the peripheral regions of the retina, it is reasonable to assume that they are the receptors activated in low and minimal illumination. Similarly, since vision becomes chromatic as it becomes central and the cone population also increases centrally, it is fair to assume that cones are the instruments of photopic, or light-adapted vision. There is, occasionally, some oblique evidence that artists are acquainted with the Duplicity theory, or at least with effects which are associated with it.

In exhibitions of painting, we regularly see large canvases in which all areas are black or nearly so. Standing before them we momentarily see no forms; but in time, marginal distinctions emerge, though not sharply, and as we look with attention at these, we begin, finally, to see central ones. This is no more than an uncommon instance of a common experience, for anyone who has attempted to look carefully at stars on a clear night has probably discovered that to look intently is to see less and that to glance is to see more. Stars emit enormous amounts of light, of course, but little of their light reaches us and they are in fact quite dark. To the retina, accustomed to responding in daylight, this is a problem. For when it responds in daylight, it responds photopically, or with vision which is centralized, sharp, and chromatic. But when it must respond in twilight, when the light has dropped to the threshold at which hues have begun to drop

out, it responds scotopically. Scotopic vision, as already described, is peripheral, comparatively fuzzy, and achromatic. This gradual and involuntary functional change in the retina, in which cones are retired and rods are simultaneously alerted, is called dark-adaption, and when it has occurred, the retina has in effect reassigned its receptors so that it can react to light of low intensity. Like a camera, the retina cannot, apparently, provide detailed information about both well illuminated and dark subjects *at the same time*. And so, when the retina reports on large, dark subjects, or on subjects which are seen in the dark, it is reporting the responses of the rods, which are concentrated in the periphery. It follows, then, that if we are to see objects in the dark we will have to gaze at positions beside them. Efforts to understand the larger role of the rods in vision indicate that they respond not only to minimal amounts of light but also to light-waves of high frequency, and that this is due to their unique chemistry.

Chromatic
Sensitivity
of Rods

Where the outer limbs of the rods and cones impinge on the epithelial layer of the retina they contain one or more visual pigments. In the rods this pigment is rhodopsin, or visual-purple, and longer lightwaves have no appreciable effect upon it. It is, on the other hand, highly reactive to lightwaves at the cool, or violet end of the spectrum, and especially to those which we call green. Everyone, surely, has seen moonlight as it strikes through clear atmosphere and vibrates against a white wall, and knows that it is decidedly blue-green. Its scintillating blue-green character has been confirmed again and again in landscape paintings, and if these leave any doubt that the chromatic sensitivity of the rods is different from that of the cones, a review of the familiar Purkinje phenomenon, described earlier, should erase it. At the same time, those who are interested in comparative anatomy and physiology say that the difference in photosensitivity between rods and cones may be evolutionary, and that rods may be prototypes of cones. This is believable, for the rods and cones in the human retina are not altogether differentiated, the one being an apparent elongation of the other, and those in the retinas of lower animals are even less differentiated. And if it is true, it means that what is evolving is a more decisive distinction between rods and cones, in function and in form, and with it a change in our capacity to see chromatically. A theory which postulates dual, or coexisting retinas should not be rejected, then, simply because it is not universally applicable. Nor should it be rejected as aesthetically

useless simply because its relevance to the work of artists is obscure. For it seems to be saying to artists that scotopic vision is not a desperate alternative to photopic vision, but a complementary and different kind, and that to see the world clearly and in detail, as in photopic vision, is not always to see it appropriately and well. It seems to be saying that moonlight, for instance, is not anemic sunlight, but a different kind of light.

If, indeed, this is the message of the Duplicity theory, it is intended for those who produce works of art which are constructivist, technological, or environmental. For in this century of technical and aesthetic explosions, as the redefining of art goes on unslaked, art works frequently evolve as objects or as events which provide their own internal, and even external, illumination. But despite their ingenuity in other respects, the conspicuous purpose of this illumination is to be adequate—that is, to be sufficient for photopic vision. Artists who produce nonstatic works in which elements, including light, are intentionally variable, may one day appreciate that as the full range of illumination is from no light to dazzling light, the full range of color sensibility is from scotopic to photopic vision.

Vision is Involuntary These complementary types of vision (photopic and scotopic) are unrelated to the modes of vision frequently referred to in the literature on perception and on art. The latter distinguish broadly between functional and artistic, or aesthetic, vision, and confirm what artists know so well, namely that we quickly perceive what we anticipate, are prepared to see, or find relevant. If a botanist and an artist are asked to comment on the color of a particular flower, visible to both, they will probably respond with different kinds of fervor. We can expect the botanist to admire its classic conformity and characteristic color while the artist will be moved by its momentary radiance and nuance, and by its relation to its surroundings as well. This argues that conditioning and awareness are the parents of attention, and are psychologically essential to effective vision. As an argument, it is incontestable. Consequently, visual perception is always in some degree volitional, or voluntary, while the decisions to see chromatically or achromatically, and with or without acuity, are not. These involuntary decisions are accounted for in the compound retinas of the Duplicity theory, but are not convincingly explained in others. Even the much-admired Hering theory, which postulates the

existence in the retina of a separate mechanism for hueless vision, is no exception.

The Hering Theory

A Theory of Opponent Colors

The Hering theory is a theory of opponent colors. It accepts the psychological primaries, red, yellow, green, and blue, as basic color sensations, and assumes that black, which is generally thought to represent the absence of stimuli, is a positive sensation. This is not an expedient assumption, for the afterimage of a white surface is undoubtedly "darker" than the sensation of darkness which we experience in the absence of light. At bottom, then, the Hering theory is psychological in contrast to the Duplicity theory which is physiological. It contends that there are six primary color sensations, that they are arranged in three pairs, and that each pair contains constituents which are antagonistic to each other. These pairs are red and green, blue and yellow, and black and white. Their constituents are antagonistic because of the presence in the retina or in cortical centers, or conceivably in the connections between them, of three visual substances, each of a different type and each corresponding to one of the pairs. The theory then turns on the notion that these substances continuously seek a state of autonomous equilibrium, and that it is achieved by the metabolic processes of assimilation and dissimilation. This means that when we look at a white surface, the black and white substance undergoes a change by dissimilation, just as it will undergo a change by assimilation when that surface has been replaced by a black one. If this is true, a state of autonomous equilibrium in the black and white substance will produce the sensation of median gray, while ascending and descending imbalances, or valences, will produce lighter or darker tones. This see-saw principle applies to other opponent pairs as well, while hues not accounted for in this way, such as yellow-red, are produced by the simultaneous stimulation of two or more pairs. Finally, Hering attributes the absence of hue in scotopic vision to a state of autonomous equilibrium in the chromatic opponents and a marked increase in the potential of the black and white ones.

Among specialists, the Hering Theory is much admired, possibly for its exceptional insight, scientific method, and internal consistency. But if it is fitting to ask of a theory, "Why should it be

so?" one must wonder why this theory postulates six physiological variables, twice the number of physical variables required to induce all color responses in mixtures of light. The colors required to do this are red, green, and blue; when two of these, red and green, are flashed onto a minute area of the retina successively, the retina reports the colors red, yellow, and green. On the face of it, this says that in the retina, at least, there is none of the opposition on which the Hering theory depends. The classic theory to which this reservation cannot possibly apply is the three-component, or tri-chromatic theory of Young. Later refined by Helmholtz, it is most often referred to as the Young-Helmholtz theory.

The Young-Helmholtz Theory

A Tri-chromatic Theory

This theory is also predicated on the existence of three visual-neural mechanisms, but specifically in the retina. And in further contrast to the Hering theory, which is vaguely psychological, it is strictly physical and Newtonian. It assumes that there are in the retina three types of receptors, each responsive to lightwaves of particular frequencies or lengths, and each corresponding to one of the three color elements in white light. It does not assume that each receptor is capable of the same three color responses, although this is certainly a theoretical possibility, but that each receptor-type responds to one of these elements. It declares, in other words, that in the retina there are red, green, and blue receptor-types, and furthermore, that they are equally inter-mingled throughout. If this is indeed the case, the relationship between physical stimuli and retinal response is uncomplicated. Some say that it is too simple, and for this reason, suspect. For as one might predict, the theory holds that yellow is produced when the red and green receptors are equally stimulated, and that magenta and blue-green, respectively, are the products of equal stimulation in the red and blue, and blue and green receptors. It contends, further, that the color sensation white is perceived when all receptors are equally and intensely stimulated; thus if we accept the sensation black as the absence of retinal stimulation, the theory accords in all particulars with additive color mixture. It is, of course, orderly and intelligible, and for this same reason, perhaps, inadequate in the face of visual phenomena which are esoteric and subjective. It does, however, allow us to rationalize successive and simultaneous color inductions; and these seriously affect relationships in works of art.

Induced color changes are subjective and illusionistic. They are also involuntary, and for that reason, predictable. Successive induction, for instance, is the predictable effect upon the color of surface *B* of our having looked first at surface *A*. If we fixate for about twenty seconds on a red circle in a white square, and then turn our attention immediately to a similar white square, we will see there a blue-green circle the size of the red one. This blue-green circle, which will intensify momentarily and then dissolve, is produced by temporal induction, which is to say that it is experienced "in time" as a natural consequence of our having looked attentively at the red one. It is an afterimage, and it is complementary, and the Young-Helmholtz theory accounts for it in a most simple way.

Retinal Fatigue On unrelieved exposure to light, retinal receptors evidently lose their capacity to react. That is, they become fatigued, and it is therefore possible for two types of retinal receptors, the blue and the green ones, to be active while the remaining type, the red one, is inactive. And so during the period of fixation on the red circle, as just described, corresponding red receptors in the retina are at work while others *in the same central region*, the blue and green ones, are not. Quite predictably, then, when we look at a second white surface, in which case all receptors in the retina are stimulated, the overworked red receptors cannot respond instantaneously as the blue and green ones can, and do. The result is that the retinal pattern of the red circle is projected as a blue-green illusion. When the retired red receptors have regenerated, as they will, and retinal balance has been restored, the blue-green illusion dissolves smoothly, as if absorbed by the white surface. This tells us that the red circle and its afterimage are complementary in hue, since restoring the red circle, and thus adding it to the blue-green of its illusion, produced a white surface once again. It tells us, also, that these hues are absolute complements, and that they are as unique as the individuals who experienced them.

Positive Afterimages However, all afterimages are not negative. If after dark-adaption we look momentarily at a brilliantly illuminated subject, we will continue to see delayed, positive repetitions of it for some time. This happens because the subject is perceived as a series of pulsating, or reverberating images. They pulsate at the rate of

about ten per second in moderate illumination, and at a more rapid rate as the illumination increases, and just what these pulsations tell the mind about color, or about distance, movement, and so on, is now anybody's guess. We are unaware of them, of course, because in normal circumstances they are spatially indistinguishable. Even so, it is not difficult to show that a perception consists of recurrent images. Against a dark background, we can first spin a pinpoint of light in a small arc and at a constant speed, to create a series of momentary light sources. This, in turn, will produce a fan-like succession of perceptions, each followed by grayer and less sustained ones, and as the speed of rotation is increased, will produce what appears to be a single perception. While this is not the usual experience, neither is it extremely rare. Who has not waved a light rapidly in the dark and seen an unbroken, luminous trace of its path. Who has not watched in fascination as the decoration on a spinning propellor multiplies, first, as a determined, rhythmic throb, and then fuses smoothly into a circumference in space.

Positive afterimages may serve many visual purposes, but it must be self-evident that they provide perceptual continuity, and that they are essential to an appreciation of movement and motion. If each perception did not linger as a pulsating afterimage and impose itself upon those which followed, all but the most rapid movements would be spasmodic and discontinuous. Suddenly, everyone and every creature would move about as if he were a bit-player in an early Charlie Chaplin movie. And so it is possible that the positive afterimage of a color, which is simply that color revived momentarily, does act upon succeeding color perceptions and make the transition from one to another less abrupt than would otherwise be the case. But even if it had this homogenizing, or unifying influence, its effect upon color relationships would be obscure at best. Fortunately, the same cannot be said of the influence of the negative afterimage.

Successive Contrast A negative afterimage is an induced image in which a change of color has occurred in the direction of contrast. Compared to a positive afterimage, it forms more slowly, lasts longer, and unquestionably affects color relationships. Two of the ways in which it affects them—called successive and simultaneous contrast—are easily verified. Having looked attentively at a red circle in a white square and then turned our attention to an alternate white square, we know that we will see a blue-green

circle there, as was explained above under Retinal Fatigue. But suppose that after staring at a red circle in a white square we were turn to our attention to an alternate *red* square which is the color of the circle. In this square we will see a black circle rather than a blue-green one. If we like the idea that a negative afterimage is produced by temporary retinal fatigue, we must conclude at once that we see a black circle because no receptors are active in the region of the retina which corresponds to the circle, the red ones because they are fatigued and the blue and green ones because they are unstimulated by red light. This may be a true explanation or it may not, but in any case it is clear that successive contrast is the tendency of every chromatic color to lay a veil of its complementary hue on a succeeding color. When this complementary veil is laid upon a surface which is in turn complementary to it, as in the instance just cited, it is of course neutralized. In successive contrast, then, the induced and complementary afterglow of one color is added later to the light reflected by a second color. But consider what happens in simultaneous, or nonspatial contrast, when adjacent colors are perceived.

Simultaneous Contrast

Imagine, first, that a square which lies on a white surface has been divided horizontally into halves which are blue-purple and yellow, both of spectral intensity. Imagine, then, that we have looked at that square attentively for some moments and have finally turned our attention to another white surface where we have transfixed it as an afterimage. We will find, remarkably, that the blue-purple has replaced the yellow, and vice versa, as in a game of musical chairs. These induced images are unavoidably bleached by the addition of white light from the background surface, and would be much more vivid if that surface were a median gray. Nevertheless, it is apparent that the color which is more intense and lighter, the yellow, has produced an afterimage which is also more intense, but darker, and that if both afterimages were superimposed upon the square, as they would be in normal, attentive vision, they would not only modify the original colors but also make them more different. They would, in other words, accentuate the contrast between them. Specifically, since these colors are already complementary and cannot be more different in hue, they would cause both to look more intense, and

the yellow to look lighter. These induced additives, or negative afterimages, can always be detected as glowing halations along the perimeters of images on which our attention is fixed, a fact which attests to the natural restiveness of the eye itself. It may also explain why simultaneous contrast occurs along contiguous edges, or along the edges where colors meet.

Differences are Accentuated

Because the negative afterimage survives as a functional change in the retina, it moves with the eye, as it were, and not with the image which produced it. If it did not, there would be no simultaneous, or reciprocal contrast, since this requires a fair exchange of afterimages between two adjoining colors. The effect of this exchange is to heighten the contrast between the two colors, and its obvious and central purpose is to make visual perception more reliable and certain. Fortunately, it helps to make works of art more resplendent, too. But all visual images are first sensed as patterns of color and then perceived, and since the purpose of perception is first of all to assure survival, it follows that distinctive color patterns are also better patterns and that the role of simultaneous contrast is to reinforce these distinctions.

Indeed, as if to dramatize its special role in perception and eventually in art, simultaneous contrast acts with most telling effect upon colors which could be indistinguishable from each other. These are adjoining colors which are imperceptibly different in hue, value, or intensity, or in any combination of these dimensions. Strangely, when they are subjected to psychological separation and stress, as they are in simultaneous contrast, these colors vitalize works of art, for it seems that colors demand our attention either because they are very different and need to be unified or because they are scarcely different and need to be clear. And finally, there is the matter of achromatic colors, which induce one-dimensional afterimages. These colors are different from others because, being hueless, they are most often "acted upon."

Induced Hues

Black, white, and the grays which they produce, have neither hue nor intensity to export in simultaneous contrast. Nevertheless, they are themselves so readily influenced by chromatic color and

so frequently changed, that one rarely sees a convincing "gray" except in relative isolation. This susceptibility to change, which is in effect an inclination to be chromatic, is easily confirmed. In the simplest of demonstrations, we can place a gray circle in a somewhat larger, intense blue-green square, and then watch for a few moments as the circle becomes red. This red will be of low intensity, to be sure, and will vary in intensity as the blue-green square does. Still, the apparent change in the color of the gray circle fits our expectations neatly, since the afterimage of the blue-green square has evidently been added to the light reflected from the gray circle. But it seems at the same time to deny our repeated assumption that simultaneous contrast always equals increased contrast. For if blue-green and gray are different from each other because one is hued and the other is not, it is difficult to see how they can be *more* different when both are hued. They can be, however, and for a simple reason.

Induction is Reciprocal

In every color circle which is theoretically sound, complementary hues are diametrically related. This means that when we speak of a difference of intensity between complements we are not speaking of their relationship to the same state of huelessness, or zero intensity, but of their relationship to each other. The contrast, then, between a red which has an intensity rating of 4 and its blue-green complement, which has a rating of 6, is not 2 as one might think, but 10. Already as different as possible in hue, these two colors are more different when the intensity of either, or both, has been increased. This is, of course, what happens to them in simultaneous contrast, and so when a gray island has been placed in a blue-green sea, to become red, and the intensity of the sea is increased, the intensity of the island will increase accordingly. But simultaneous contrast is reciprocal, and one must ask what effect the island has upon the sea? It apparently will modify the color of the sea in the direction of greater value contrast, a lighter island producing a darker sea. We can confirm this change without difficulty by aligning several identical blue-green seas and placing an island of different value in the center of each.

Although no one doubts the validity of such demonstrations as this, many have reservations about their usefulness. They say that we do not often see colors in such rarefied and sterile circumstances, and therefore do not know how much they have been influenced by surrounding colors. And they are right. But it is not so important to know how colors have been changed by their

environments as to know that they can be, and to know that every color, as it is moved about, readjusts again and again to environmental stress. Few things are more frustrating, for instance, than matching a small area of color in a painting when the mixing surface is drastically different from it. Artists do this regularly, and in resignation; and if their tireless stirring and stabbing does not attest to their artistic dedication, it certainly does attest to the volatile nature of simultaneous contrast. Even so, it is the amount of this kind of contrast which baffles artists and others, not its behavior, for in a standard demonstration in which a color X is acted upon by several which are different from it, the directions in which X will change can be reliably forecast.

Predicting Contrast

Suppose that three squares are joined to make a horizontal strip, and that a relatively small square is placed at the center of each. And suppose that these small squares are yellow of median value and moderate intensity, and that our purpose is to change each in a specific way by filling the larger squares with an environmental color. By adding a blue-purple of higher value, we can make the first of these squares look darker and more intense; by adding a red-purple of lower value and greater intensity, we can make the second square look greener, lighter, and less intense; and by adding a less intense blue-green of the same value, we can make the third square look redder and more intense. Nothing would be accomplished by multiplying these instances, since it is already clear that competitive areas of color act upon each other in the directions in which they are different. We might, then, have demonstrated this principle as well by establishing three large yellow squares and then prescribing the colors of the small squares at the center of each. But if we had, the yellow which was so markedly influenced when surrounded by other colors would have been affected only slightly, if at all. This indicates that simultaneous contrast is effective only in situations in which there is a high degree of convergence and central fixation; but this kind of contrast occurs along contiguous edges, and in this instance, merely affects a relatively high percentage of the central area. And if this area were not square but irregular in shape, so that its perimeter were longer, the alteration in its color would be even more pronounced.

Contrast and Symmetry	Since induced color effects are present in works of art for all to see, an understanding of them is not really prerequisite to an appreciation of the works. But this understanding is surely a practical asset, and a practical necessity, in the performing artist. The reason for this is as plain as the necessity to maintain balance in color relationships. The balance between any two colors is the sum of their differences, and so if one of these colors is changed in any dimension when they are seen simultaneously, this balance is disturbed. And what is more, this disturbance is compounded by simultaneous contrast. In practical language, this means that when we make one color change in a work of art we involuntarily produce a second change which is different from it. Is this important? Always, and particularly in works in which color relationships are few and finely balanced.

Consider a situation in which a dark, intense red circle is seen against a light, unintense red-purple field. We will find when that field, or background, has been changed to a lighter purple, that the red circle has shifted subjectively to another region of the spectrum and has become slightly yellow-red and darker. If we intended to change only the red-purple field, we have nevertheless changed the red circle, too, and must adjust its color in order to accomplish our purpose. We can do this, of course, by making the once red circle lighter and slightly red-purple. Although we can always compensate for reciprocal changes in this way, we do not, as a rule, resist them. Perhaps we do not because we appreciate that they are natural and inevitable, and often enhancing, just as the sailor knows that it is best, in the long run, to roll with the sea.

Working Assumptions	Since simultaneous contrast is structured into vision, and like death and taxes, will be with us for some time, it is difficult to argue that its effects should not be used knowingly. This means that as we adjust colors to some aesthetic, or at least purposeful end, we should exploit the fact that every meeting of two colors is, for them, an identity crisis. We can exploit this fact if we remember that every color attempts to make adjacent ones complementary in hue and slightly more different in other dimensions than is really the case; that complementary colors, which reinforce each other by becoming more intense, are the exception to this rule; that in noncomplementary juxtapositions the less intense color always diminishes more in intensity as it migrates in hue; and that every attempt to produce colors of

identical value will be resisted by our natural inclination to drive them apart (see Plate 4). Such working assumptions as these, and many more, say that the phenomenal effects of simultaneous contrast are accessible and clear. Regrettably, the same cannot be said of the cause, or causes, of the negative afterimages which produce them. For despite the tempting simplicity of the retinal explanation of Young and Helmholtz, investigation may yet disclose that the cause of these phenomena lies, in part, in more remote regions of the visual mechanism, including the mind.

According to Young and Helmholtz, negative afterimages are produced by transitory changes in the retina. This may be true of course, for in vision the first observable physiological changes occur there, in the receptors. But the manner in which neural impulses collect retinal data and convey it to visual centers in the cortex, and the process by which this data is interpreted in the cortex as sensation, perception, and relation will not now submit to total understanding. Significantly, this line of inquiry is inward, since color vision is an external-internal series of events, and between the external events and the mystifying internal ones is the retina. The retina belongs, then, to both and to neither; it is, in Leonardo's words, "a window on the mind." And although this window is not altogether clear, neither is so clouded that it destroys the view.

The Visual Pathway

Looking at the retina and beyond, we can imagine light in the form of neural energy moving rapidly to the optic nerve through an elaborate pattern of nerve fibers, much as vehicles moving along traffic arteries converge upon a central city. Moving as impulses, this energy enters the optic tract, even as this tract converges within the skull and joins its counterpart from the other eye. Joined, these tracts form an X-shaped structure called the optic chiasma, and at this point selected nerve fibers from each tract separate and cross over to create two restructured nerve bundles which diverge toward the back of the skull and terminate finally in what are called lateral geniculate bodies. Each of the latter is a relay station, stratified so that alternating layers contain fibers from opposite eyes. The lateral geniculate bodies apparently coordinate binocular impulses and have a part

in color discrimination as well, for the nerve bundle which reaches the right body, for instance, conveys retinal impulses from both the nasal region of the left eye and the temporal region of the right eye. From each geniculate body, three sets of nerve fibers then radiate to brain centers. Two of these affect involuntary movements of the eye and spatial judgments, and the third, which leads to the occipital lobe of the visual cortex, presumably fuses all messages from the retina. It leads specifically to the visual cortex, which bears a point-to-point relation to the retina and evidently transcribes what happens there.

Physiological Influence

The interior mechanism of the visual pathway embodies the complexity and irresistible mystique of life itself. For when we recognize that an emotional response to color was first a perception, and before that a collection of sensations, a bundle of neural impulses, and a retinal mosaic in the visual cortex, we certainly suspect that it originated in the deepest layer of the subconscious. But the visual pathway keeps its secrets well; and this is unfortunate, for it is probable that our responses to color are conditioned by the way in which information about the world outside ourselves is encoded and decoded there. One is inclined to agree with those writers and artists—Sir Herbert Read among them—who contend that the formal elements in works of art evoke responses which are psychological and perhaps physiological in origin. One is inclined to agree, in other words, that our initial responses to color may be bodily reactions. Without a doubt, the discomfort that we experience in the presence of intense complementary colors is such a psycho-physiological reaction, as is the stress we feel in the presence of art works of extraordinary luminosity. Thus it seems that the Fechner law, much on the minds of contemporary artists, is as much a law of physiology as of perception.

The Fechner Law

The Fechner law says that when the illumination on a color of median value is gradually increased, we will perceive quickly that the color has become lighter, and that this increment of perceptible change, whether it is added or subtracted, is fairly constant for colors in the middle value range. If, however, we

gradually change the illumination on a color of high or low value, the increment required to produce a perceptible difference will be much greater and will increase as the color under consideration approaches white or black. Our diminishing sensitivity to change is evidently more marked in the lower value range, and especially affects colors of longer wavelength, such as red. A fair interpretation of this law is that we can make more value distinctions in the middle and upper value ranges than in the lower one, and that in the lower range we can make more distinctions among colors of short wavelength, which are generically blue. This correlates in principle, if not in detail, with the Duplicity theory of color vision and the Purkinje phenomenon, mentioned earlier. But whatever the meaning of the phenomena with which Fechner is concerned, their cause lies, undisclosed, in the complicated relay mechanism of the visual pathway and in the mind.

Discovering Relevance

The Fechner law is a symbol of the uniquely modern conviction that *any* evidence which adds to our understanding of the visual process is relevant to the visual arts. It probably is, too, if that relevance can be discovered. But the ability to make relevant connections is still rather rare, and the evidence which bears upon the visual process is massive and growing. After all, this evidence may be provided by those who are in fact concerned with the physical behavior of light, with optics, with the anatomical and physiological structure of the eye, with neurological activity in the retina and in the visual pathway, with the nature of visual sensation and perception, with visual symbolism, and finally, with the tempting mysteries of the subconscious mind. So the visual process is a very long chain indeed, from the structure of light to inner-directed symbolism; and it is likely that every artist can find in it *his* kind of relevance—that is, the kind of relevance which is complementary to his purposes and allows him to function as an artist. Moreover, the kind of relevance which he finds will influence his decisions about color—about how he will select colors, and about what they mean.

Selecting Colors

It is plain that "op" artists use colors which allow them to exploit the natural, functional characteristics of visual mechanisms, and that Expressionists turn naturally to colors which they feel are subjective, irrational, and symbolic. But in the absence of such specific purposes as these, we can only suppose that the artist selects colors because they are the colors of the subject,

because they appeal, in an ill-defined way, to subconscious memory, because they are reminiscent of past successes, or because he is frankly and randomly searching. It is probable, too, that his color decisions will reflect first one vague purpose and then another, since it is quite usual for a work of art which imitates the colors of its subject to become more meaningful when, at a later point in its development, it does not.

The Structural Sense

CHAPTER THREE

Having chosen colors for reasons which are always personal and possibly speculative, artists of every persuasion manipulate them in similar ways, so that their relationships are unified, clear, and above all, interesting. This manipulation is structural, since the artist uses colors which support and strengthen his intent, and since colors do this only when the artist perceives that they are orderly, appropriate, and relational. The readiness to perceive this kind of relatedness and coherence, whether in the artist or in the observer, and whether in visual art or in another art, is "the structural sense."

All Elements are Perceived in Color

In the visual arts the structural sense is inseparably tied to a conception of the work of art as an "object," and this in turn is tied to one's capacity to recognize the elements of visual perception which constitute it. Color is, of course, one of these perceptual elements, and although elements are by definition essential and irreducible and therefore equal, color may well be, as in George Orwell's famous phrase, "more equal." If this is so, it is because all visual images are necessarily sensed and perceived and eventually expressed as chromatic or achromatic differences of color. A pencil line is visible only because it is different in color from the surface on which it has been drawn; and we recognize the pencil, itself, only because its contrasting lines and areas of color present configurations, or patterns, which we perceive to be a pencil. It is apparent, then, since color contrast is in some ways synonomous with vision, that color is a constant element in works of art which are visual. With this, no experienced person can disagree.

The Elements of Visual Perception

There is widespread agreement, too, that the elements of visual perception, exclusive of color, are lines, planes (areas and surfaces), volumes, spaces, and textures. This consensus is anything but unanimous, however, for while everyone knows that elements of visual perception exist, and indeed that they must exist, artists and those who write about art are at odds over the particulars. Traditionally, for instance, a line is a visual element but a "dot" is not. Now, no one seriously doubts that lines and areas are elements, and so if we accept this long-standing distinction it must be because we think that a dot, since it is both static and shapeless, will be perceived as a line when it is no longer static, as in a succession of dots, or as an area when it is no longer minute and shapeless, as when it has become a circle, for instance. There is even some doubt that "shape," long an established element in works of art, can really be one. Those who dissent argue that shape is properly an attribute of all elements except color and texture, and that it represents the distinction between a straight line and a curved one, or since volume is also an element, the distinction between a cylinder and a cone.

The Attributes of Elements

To the artist, certainly, this kind of argument is specious, for he works with a perceptual system, not a conceptual one (in which a

dot is a point in space, and a line is defined as that same dot moving in space), and he knows that in a perceptual system things are as they *appear* to be. He knows, therefore, that a line is what looks like a line, and that it is quite impossible to perceive a line and respond to it without perceiving its shape also. Perhaps we should assume, then, that shape is the principal visual attribute of lines, planes, volumes, and spaces. And if we accept the condition that shape, and possibly size, position, and direction, as well, are the infinitely variable attributes of visual elements such as lines, it follows that hue, value, and intensity are the variable attributes of color. But even more importantly, it follows that it is the attributes of the elements of visual perception, not these elements themselves, which create the internal relationships which make works of art unified, clear, and varied, or interesting.

The Nature of Structure

A work of art is structured, then, when the attributes of its elements are perceived to be relational. This implies clearly that a particular work of art may be structured to one person and not to another, and that even those who respond to its structure may be somewhat vague about all but its most conspicuous features. The last is especially true of those who have no desire to produce works of art but who want, nevertheless, to enjoy them, for they are all too often convinced that a refined knowledge of structure is not necessary to an informed appreciation in the visual arts, or in any art. They identify structure with analysis, professional jargon, and bloodless diagrams which are not often illuminating, and are pleased to dismiss it as "the artist's problem." They are, of course, quite wrong on the one hand, and quite right on the other.

To be sure, visual structure is an analytical and somewhat technical subject, and it can be formidable if the learner is ill-prepared or sluggish. Moreover, it *is* the artist's problem, always, for it is clear beyond doubt that the artist who cannot structure, and who for this reason cannot control and master the interrelation of parts which gives character and completeness to the work of art, simply cannot function. He is as effectual as an archer with a bow of stone and an elastic arrow, and every day, in art schools everywhere, young artists face this uncompromising

fact of artistic life. For them, devising expressive forms will soon be a way of life. But others, seeking only an increased awareness in the visual arts, should not ask whether the study of structure is demanding, nor whether a knowledge of structure is critical in the performing artist. They should ask, simply, whether structural insight can make the intention and spirit of the artist more vivid and accessible.

Structural Awareness and Response

The artist and his audience share a unique relationship in which the interests of the one, slightly modified, are the interests of the other. It is the kind of personal and dependent relationship which makes allies of teacher and learner and of writer and reader, for the artist and his audience are opposite faces of the same coin, with the work of art compressed between them. If the one is action, the other is reaction, and if the one is expression, the other is comprehension and interpretation. And of course, if the one cannot function without structuring, it follows that the other cannot react without a comparable sensibility. The artist does not, after all, structure in order to make his work inoffensive or even agreeable, but to infuse it with a feeling of purpose, or intention, and the viewer, in responding, must discover this essence. It is fair to assume that the viewer can do this only if he is sensible to visual relationships in the work and if he is aware of those relationships to which the artist, consciously or otherwise, attaches significance. In short, he can do this only if he possesses a structural sense.

Appreciation is not Praise

From the point of view of the observer, as much as from that of the artist, the structural sense is a special kind of appreciation. This is true, however, only if appreciation is not carelessly equated with praise, as is so often the case, for there is little doubt that the casual substitution of one for the other has encouraged those who like a particular work of art to feel that their pleasure in the work automatically constitutes an appreciation of it. Their pleasure might indeed be appreciation. But appreciation consists in appraisal, not merely in praise, and it may well be, for instance, that we devalue a work of art precisely because, by combining knowledge and experience with insight, we have reached a determination of its worth and find it wanting. This means that we can like a work which an appreciation tells us has little intrinsic worth, just as we can dislike a work of historic and philosophic importance. The paradox here is intriguing and real,

for there are many who acknowledge the importance of the painting, *A Sunday Afternoon on the Island of La Grande Jatte,* by Georges Seurat (Plate 6), but do not really like it.

They probably find that this painting defies their hopes and denies their expectations. They may be convinced, for instance, that science, or system in any form, is inimical to the nature and purposes of art. They may wish that the aesthetic lightning called modern art, perpetuated in this painting and in others, had never struck. And they may be persuaded that works of art should be passionately distilled and therefore unsupervised by the intellect. But they know at the same time that artists have the right and even the obligation to define and redefine art in what they do, that the challenge to convention and tradition which this painting represents was inevitable, and that the work of art is a trans-figuration of the artist as a whole and unique person.

They may be convinced, too, that artists should concern them-selves with ideas of universal dimension, and that Seurat has not. They may even wish that his painting were more eventful, and that its figures, staked to the ground as if in suspended animation, were less monolithic. They know, nevertheless, that there are no "approved" ideas in art, since artists simply concern themselves with life as it is illuminated by their experience; that it is the stoic mood of this painting, undisturbed by major incidents, which underscores the fact that its forms are scrupulously formed and sensitively placed; and that it is by virtue of its architectonic spirit that the painting, filled to capacity with forty-odd figures and animals, achieves an unexpected elegance. All this being so, it is obviously possible for those who do not enjoy this painting to appreciate that it was, in its time, adventurous and inspiring, and that it is even now a structural tour de force, complex and im-pressive.

Response for Appreciation Perhaps it is because there are so many ways in which a work of art can be appreciated that its structure is so often ignored. We appreciate a work, certainly, when we place an informed value on it in any relevant context. We do this, for instance, when we recognize the historical meaning in the wounded bison in the caves of Altamira, the social and satirical thrust in the works of Daumier and Hogarth, the biographical importance in the works of Rembrandt and da Vinci, the aesthetic impact of the works of Monet and Kandinsky, the innovative influence of Picasso and

Moore, and of course, when we recognize the significance of unconstrained imagination in the works of Miro and Chagall. To be sure, in a truly important work of art these appreciations can converge, especially if the work has tipped the uncertain balance on which art history turns. That they do converge, and that appreciation is multiphasic, is well illustrated in Seurat's painting of *La Grande Jatte*.

The painting is a blend of personal and scientific attitudes toward light, and its familiar divisionist technique, which produces the illusion of atmospheric color within as well as around objects, is a classic example of the technical and aesthetic aims of Impressionism. As one of the first attempts to make allies of science and art, and as a stunning digression from the center of traditional thought, the painting was a tribute to the personality and will of the artist. And of course, we recognize now that it is a resourceful plastic organization of consummate skill. A random appreciation of the work reveals that it is these things, and perhaps more, but a discerning appreciation recognizes at the same time that only the last can seriously be called artistic. For only its plastic organization, since it asks the viewer to respond to the work in such a way that it becomes *his* experience, asks him to exercise that special sensibility which is the structural sense.

Artistic Appreciation

The distinction between an artistic appreciation and other kinds is often unclear, or worse. Many do not understand, apparently, that the information, experience, and interest which they bring to a work of art will necessarily determine the kinds of appreciation of which they are capable. They do not recognize that the posture of the art historian, which might cause him to conclude that Seurat's painting is the first tremor in a quake which is still rumbling, is not the posture which might cause a critic to describe this painting as a technical and expressive triumph. The evidence which supports the first opinion will not, in itself, support the second, and although in the long run both points of view are necessary to a complete understanding of the work, and may even be complementary, they are surely not the same. They are, as a rule, contrasting assessments of the same work, and all too frequently the viewer who is capable of the one is incapable of the other.

Even though it is clear that every kind of appreciation is informed in a special way and provides its own kind of access to the work of art, many continue to accept any knowledge of the work as unconditionally useful. Any knowledge is preferable to none, of course, and more is preferable to less, but knowledge which is not strictly relevant may be misleading. Confronted by a work of art about which much has been said and written, an informed viewer can produce the glow of an artistic appreciation where there is no fire. By invoking a knowledge of the theme of the work, of its aesthetic premises, of its place in the narrative that is art history, and of the artist, he can illuminate the work without seeing the light which is in it. He can know the work but remain untouched by its magic as a record of some rare moment of human experience which he can share. He can fail in the end to respond to the work as a visual statement, and what is infinitely worse, be unaware that he has failed. Such failures, which are the most dismal in art, are failures of the structural sense.

Cultivating the Structural Sense

How then, if one does not produce works of art, does he cultivate and inform his structural sense? Not by unending exposure to works of art, certainly. This is never harmful and is sometimes enlightening. It is most often vapid, however, for the work of art does not send out predigested meaning, as a searchlight sends out beams. Instead, it asks the viewer to reach out discriminately and to respond. And he will, involuntarily. But he will respond to what he is prepared to discover in the work rather than to what the work is prepared to tell him; and the structural sense, since it prepares him to see the work as the artist might have, will allow him to discover its elemental conformation. Still, there can be no structural sense, and consequently no discovery of this kind, unless there is first an awareness of the work of art as an object.

The Structured "Object"

The word "object" is used here in a highly specialized and restricted spirit. It is not a reference to the work of art as a physical object such as a painting, a sculpture, or a building. It stands, rather, as a concept of the work of art as an independent visual form, and as an ordering of those elements which, in one way or another, can be said to inhere in all works of art. Such a complex of elements, which is a complex of lines, planes, volumes, and spaces, and of colors and textures, is curiously inseparable from the work of art in the way that the human

skeleton is inseparable from the human form. No one would contend that the skeleton *is* the human form, and yet it is as easy to imagine a rose without petals, or a centipede without legs, as to imagine the human form without a skeleton to give it stability, proportion, and articulation. Similarly, a work of art which is not an object, and which does not derive its distinctiveness from this fact, is a myth. And so although it cannot be said that the work of art is *only* an object, it can be said unhesitatingly that it *is* one. This the artist knows very well. For him a clear conception of the object is an inescapable necessity, for it is the object which he forms as he works, structuring relationship upon relationship until fitness and equilibrium are joined, and until an addition or subtraction would be superfluous or ruinous. Unfortunately, the nonperformer must discover the object by a different, more obscure, and in some ways more difficult route.

The object is irreducible form; it is what remains of the work of art when, by an act of imagination, it has been stripped of its subject matter, content, style, function, materials, technique, and indeed, of every attribute which is extractable. It is by this process of imaginative reduction, or distillation, that the object is revealed as a complex of lines, planes, colors, and so on, all locked together psychically in space. But unfortunately, the undistracted, selective vision which this process demands of the viewer is neither naturally nor easily acquired, and so it is not surprising that for many the object is as elusive as a shadow on a cloudy day and just as blurred at the edges. It is not easily acquired because, to the extent that a work is artistic, it is as visually indivisible as the artist can make it; and it is not naturally acquired because most viewers are unwilling, even for a time, to suspend their consuming interest in other aspects of the work, and particularly in its subject matter.

Narrative Subject Matter

The appeal of subject matter and of content, which is the gist of subject matter, is understandable and even desirable, for the subject of a work of art does matter. It matters to the artist, who obviously thinks that it is appropriate and necessary. And it certainly matters to the viewer, since it is through the mediation of subject matter that he connects the work of art to life and sees it, whenever possible, as an extension and realization of his own

experience. This is a normal and predictable reaction, and it may be the route by which important psychological insights are reached. But regrettably, this kind of interest too often leads the inexperienced viewer to a wholly unjustified feeling of artistic involvement. In Seurat's painting of *La Grande Jatte,* for instance, the lure of the subject is irresistible, as it always is in works which are broadly social, and it leads unmistakably away from the object, away from a structural response, and away from an appreciation which might even cautiously be called artistic.

"La Grande Jatte" This painting (see Plate 6), is about people whom the Western viewer knows well. He sees instantly that they are players in a minor drama which has been repeated with local variation for centuries. He sees that they have gone this time to the island of La Grande Jatte to perform that most important of communal rites: working hard at doing no work on Sunday. The painting comes through as an elaborate tableau on a natural stage, with discipline and ritual as its central theme. Even the children portrayed there, indifferent to a tradition which they do not understand, are apparently acting out roles in a play that has had a long run. The low-key theatricality of the painting, emphasized in its format, insists that the viewer remain in front of and outside the work; but the psychic distance between the viewer and the work is not great in any case, and he is invited by its comforting and ingratiating subject matter to develop the theme of the painting in his own way and on his own terms.

Association The invitation to elaborate on subject matter by completing it as a
and Mood narrative or by embellishing its mood is one which few of us can resist. And so, in reacting to Seurat's painting, a viewer might be continuously enchanted by the warm, clear light which pours into every space. He might imagine that a bird has just fluttered aimlessly across the clearing, and after a momentary hesitation, plunged into a tree. He might even imagine that he hears a mother's crisp command, and from a distance, a child's indifferent, melodic reply. He might reconstruct these moments and many more as he moves, in an expanding circle, into his own experiential world and away from an artistic concern with the work. But an interest in subject matter can, of course, carry his attention into the work as well as away from it. It can burn itself into the object as well as into his remembered past, and in so doing, produce a new set of revelations and a new experience. And so it is not merely an interest in subject matter which diverts

101

the viewer from the structural implications of the work of art, but a fascination with it. This fascination prevents him from recognizing that the vitality of the subject emerges when the object is perceived simultaneously and is indistinguishable from it.

Elements and Subjects
It is clear that psychological order—which is the thrust of subject matter—and structural order—which is form—coalesce in works of art, and that we have acquired a structural sense when we can, at will, perceive them separately as well as together. We can do this when we are able to distinguish between elemental parts and their figurative and associative meanings, and this is a matter of orientation. When a tree for instance is well illuminated, it is a series of cylindrical volumes, its branches represented by volumes of diminishing size. But when this same tree is distant and perhaps silhouetted against the sky, it is an involved pattern of lines. Given these circumstances, everyone will perceive that he is looking at the same tree, but the person who has a structural sense will also recognize that its images are quite different. This is a routine transformation in nature and a critical one in art, for if we are to make the subjects of visual statements relational, we are well advised to know how they are elemental and in which ways the attributes of their elements can be related. If, for instance, it were necessary to visually relate the near and distant images just described, we would not relate tree to tree but volumes to lines, however that can be done.

Color as the Perceptual Element

Because the artist structures in this way, distinguishing always between the marks which he has *in fact* made and the subject matter associations which they generate, the viewer must make the same distinction. This means that in the painting by Seurat the trunk of a distant tree is also, and foremost, a line, and that as a line it has attributes of size, shape, and axial direction which cause it to interract with the attributes of other lines and with other elements. In these interactions color is constantly a factor, both as an attribute of lines and areas and as an element which itself has attributes of hue, value, and intensity. In this respect it is unique, for in works of art, as in situations which are normal rather than clinical (a view of the central area of a 4' x 4 red panel from a distance of 4" is clinical), we never see a color which

is not at the same time an attribute of a line or an area. Naturally, then, we never see a line or an area which is not colored. It can even be argued that lines and areas of color are *the* elements of visual perception, that they lie on the fringe of consciousness and that we sense them before they have been perceived and have acquired any meaning.

Between Sensation and Perception

Aldous Huxley has written vividly of the first phase of his recovery from anesthesia, during which he experienced raw, nonreferential color sensation, or what he calls pure *sensa,* and of his gradual return to a normal perceptive state. He states that for some moments at least, these patches of color were suspended between sensation and perception. And the philosopher Ortega y Gasset has described with disarming simplicity the way in which artists, as if by an act of aesthetic discipline, delete subject matter from their primary visual experience. This capacity, which he defines as the capacity to see the world, including works of art, as two-dimensional mosaics of color, he calls artistic vision. If he is right, the structural "object" of the artist may be no more than an extension of this kind of vision, and in its most simple form, a set of relationships in which colors acquire attributes of size, shape, position, and direction. When this happens, as it must, we perceive a color mosaic which is called a Gestalt.

Closure and Gestalt

Instantaneous Unity

The word Gestalt, which means form, stands for our tendency to perceive visual patterns as unified configurations. Accordingly, in a Gestalt we seize a visual experience instantaneously and whole, as in a single perception. We do this because we are psychologically driven to make the experience symmetrical and complete, and this necessity in turn requires an act of closure in which each of us imposes his own order upon it. We have imposed this kind of order when we recognize that three quite separate marks are, or could be, parts of the same implied triangle, for example, and there is no doubt at all that the capacity to achieve closure, which is the capacity to perceive relationships, is an essential ingredient in the structural sense. Each work of art evolves in its own way, of course, but despite this diversity, the strategy of the artist is surprisingly constant. He hopes to reach a simplified sense of the whole as quickly as possible, and having done so, to refine and clarify until all relationships look in-

terdependent and inevitable. And so although a Gestalt is perceived instantly, if at all, it is not refined instantly in the work of art, and the first responsibility of the structural sense, in appreciation as well as in performance, is to recognize in the work those visual interconnections which make it whole. Reason insists, then, that each recognition will be followed by others of different emphasis, and that the work of art is structured as a succession of configurations.

Attention and Movement

The perceiving and relating which is here called the structural sense is not something which we do to the work of art, but something which we do in response to it. It is, then, attitudinal and attentive. We may be sure, for instance, that when the artist refers to movement in a static work of art he is alluding to the way in which his attention shifts as he reacts and adjusts to clues which lie in the structure of the work. We know that these clues induce movement, for there is an unquestioned correlation between the way in which we see and the way in which we give our attention to what we see. We need not look far in order to confirm it, either. At a given moment we can give serious attention only to images which form in the central region of the retina, and give prime attention only to those images which lie in the minute, cone-congested region of the central fovea. This means that as we look at this page of type from a distance of approximately sixteen inches, which is normal for reading, our linear focus is about one-half inch and our precise focus is much less—perhaps the width of a letter. This suggests that we see each letter clearly only when we see it individually, and that we see words, paragraphs, and this page itself, as a succession of rapid and overlapping perceptions. It is fair to assume, certainly, that we visually summarize the work of art in a comparable way, and that we give our attention to it cumulatively, as in a succession of shifting configurations. And so if it is by responding to configurations, first in one place and then in another, that the artist "attends to" a work of art, it is apparent that the work is structured when it expresses the kinds of attention which he sought. Thus, it is complete, for him, when it harmonizes with the structural principles which he respects.

Structural Principles

Shared Convictions

Typical structural principles are unity, clarity, and interest. Presumably, they represent three conditions to which all works of

art aspire. But even principles of this kind are no more than a consensus which may vary greatly from culture to culture, from place to place, and from time to time, for they simply attest to an apparent willingness among artists to conform by sharing the philosophic purposes and stylistic convictions of their contemporaries. This is an honorable thing to do, and it largely accounts for the development and refinement of historical styles. Moreover, it allows us, at any time, to deduce structural principles with confidence. Still, when we assert that works of art should be unified, clear, and interesting, we are merely saying that in the works of our contemporaries, and probably in our own, this is evidently true. At the same time it is tempting, after widely-accepted practices have been canonized as principles, to insist that there are structural laws too. For if principles declare our ideals, laws give us a means of achieving them. This is why we are told that unity is a principle and repetition a law, that clarity is a principle and emphasis a law, and that interest is a principle and variation a law. It is also why, as we descend from principle to performance, we are told that pattern is a device of unity, that domination is a device of clarity, and that contrast is a device of interest. As we complete this orderly descent we will find that principles, laws, and devices are served, finally, by the ways in which the attributes of lines, planes, volumes, spaces, textures, and colors, the elements of visual perception, are related and orchestrated. The capacity to respond to this orchestration and to appreciate the way in which it serves the artist's intent is, again, the structural sense.

Although the artist selects colors for reasons which are affective or emotive and often obscure, he manipulates them for reasons which are structural and fairly clear. Consequently, a response to the color in a work of art should answer at least these two questions: Why, probably, were these colors (hues) chosen? In what ways have they been related, and to what end? In order to illustrate, we should perhaps look again at the Seurat painting, Plate 6. It is, as anyone can see, an impeccably tranquil painting in which physical action has been suspended as if eternally, and in which figures are ordered so that each respects the privacy of others. Its distinguishing feature, however, as in all Impressionist paintings, is its light. This has been produced additively, by pointillism, and as it spills into every cubic inch of space it lays a haze over the forms and affects their colors. Nevertheless, the trees and grass in the painting are green, the water is blue, and

although these colors are not strictly imitative, unless to those who are deplorably unfamiliar with natural phenomena, it is apparent that they were suggested by the subject. It seems that the colors of the painting were chosen because, in the subject, they were there. In this respect, they are certainly routine.

The Color Mosaic

The Picture Plane But only natural subjects are predictable in color, and *La Grande Jatte* is filled with human ones. This gives the artist some latitude in selecting and distributing colors; but before considering the way in which he has used it, we should consider how we shall appreciate it. There is in art, and specifically in the "science" of linear perspective, a theoretical element called a picture plane. This plane is the surface on which the artist draws and paints, if that surface is transparent, and so if we imagine the way in which paintings are created, it is clear that the subject of every painting exists (or is perceived to exist) in the space beyond this plane even though it is *in fact* lines and areas of color marked *on* it. This means that by making a visual adjustment we can alternately see either the raw material of the painting as it lies on the picture plane or the things which we perceive this raw material to be. This is a critical distinction, since it allows us to separate non-referential lines and areas of color, all lying on the same plane, from the things in space which we perceive them to be. It is not very different from the distinction drawn by Aldous Huxley when he asserts that visual images emerge from the subconscious as vaguely sensed lines and areas of color, or as two-dimensional color mosaics, and are then perceived. He is saying that an illuminated volume, such as a cone, is no more than a mosaic of color which we finally perceive or recognize as a cone.

The Pictorial Space Compressed It is not difficult for the painter to recognize that he begins his work by marking the surface, and that he proceeds at his own pace to deal with its developing intelligibility, illusions, and tensions. But if we wish to examine the marks which he has made, we must reverse his procedure and press the painting, as it were, into a color mosaic. Suppose, then, that one can reach behind this Seurat painting of *La Grande Jatte*, and push the sky toward the picture plane, pressing it against every overlapping form so that there is finally no pictorial space. The result will not be the painting compressed, to be sure, for grape juice can never be a

grape, but it will allow us to see the color of the painting without the intrusion of other elements.

Looking at this compressed mosaic, we see at once that to massive areas of yellow-green, green, blue, and blue-purple, the artist has added a series of yellow-red punctuations. These accents are distributed in counterclockwise fashion in the painting, and although the decision to make them uniformly yellow-red was undoubtedly optional, it was not arbitrary. For in making them yellow-red the artist has added the hue which complements the green and blue-purple hues which were there. These three hues, mixed additively, can produce all hues and most colors, and to a pointillist like Seurat, this was a matter of some consequence. His conscious interest in them can be confirmed easily enough, for it was a rule of thumb among nineteenth-century painters that the work of art evolved organically, or from the inside out, and that its elements could always be discovered at or near its center. Their reasoning was that the seed necessarily contained the genetic visual characteristics of the whole, and in this case at least, it did, for the color plan of this painting can be found in miniature at its center. There, in addition to major areas of color which are yellow-red, green, and blue-pruple, are a few which are blue or white, and all of these taken together are characteristic of the painting.

Effective Color

Emotional Fitness

Compared to those in most contemporary works of art, the color relationships in the Seurat painting are frankly unexciting. They are scintillating because they have been produced additively, but they have been dictated by the demands of "local" color and their aesthetic role is undeniably supportive. Still it may be that this conclusion begs the question, and that the question is not whether color is more exciting in one painting than in another, but whether we are convinced of its emotional and structural fitness in either case. And if this is indeed our measure, the color in this painting measures up. We may assume, for instance, that atmosphere is important to the success of every Impressionist painting, and further, that "atmosphere" is merely illumination characterized in color. Certainly, then, since the atmosphere in this painting is consistent and believable and even somewhat unusual, its color is effective. It is all the more effective, too, because it creates an atmosphere which denies our usual expectations.

Nature Contradicted

We expect forms to be obscure when they are in shadow, and we expect the edges of shadows, especially when the shadows have been cast from a distance, to be indistinct. Nevertheless, the shadows in this painting are crisp and immobile, and do not really embrace and absorb the forms which are in them. We also expect surfaces which are presumably the same color to be slightly different in color when they are either near or very distant. But in this painting the bank of the canal, vibrant and yellow-green in the foreground, is the same color at its most distant point in deep space. The net effect of this kind of contradiction is a rarefied atmosphere in which a warm, gentle, and unoppressive sun lights every form with unnatural brilliance. This, surely, is what the artist wanted. But when color is emotionally supportive, it is as a rule structurally supportive too. And so we can safely predict that if hue contrast were extracted from this painting it would continue to be quite readable in value. It would not be completely readable, however, for many of its meaningful contrasts occur where there is little value contrast or none. These minimal contrasts are planned, and there is a sound structural reason for them.

"Passage"

An Inventive, Additive Process

Used effectively, color will make the work of art more clear, interesting, and expressive. But along with other elements, it must first of all make the work coherent. That is, it must provide some of the glue which holds the parts together. To this end, artists have always adjusted the contrast between adjacent areas of color, and these adjustments may even now constitute the most common and necessary structural maneuver in painting. It seems that as we react to a painting our attention circulates, and that it circulates along routes of least visual resistance. It does this because every area of color, when surrounded by others, allies itself with those areas which are *least* different from it in color, and particularly with those which are least different from it in value. This is more clear, perhaps, if we imagine that every area of color is surrounded by a wall of contrast, and that our attention and interest, as they break through this wall where there is least resistance, simply add a second area, and then a third, and so on, to it. In any case, it is by such an additive process that the color mosaic of a painting is assembled and formed. And because it is freely improvised, this mosaic is free of the descriptive limitations of subject matter. It is possible, for instance, while producing a

painting of a flower against a cluster of leaves, to create a color mosaic which derives from both but is quite independent of them.

"Passage" Seurat was certainly no stranger to this maneuver, and used it resourcefully and often, as every painter must. His concern with what he and his contemporaries called *"passage"* is evident everywhere in his painting of *La Grande Jatte* (see Plate 6). It is nowhere more conspicuous, however, than in the central area of the painting, where relationships always seem more crucial. If we give our attention to the central foreground, we will see that the figures seated there are, in effect, a variation in the edge of the foreground shadow. The ground and the figures, both in shadow, are virtually indistinguishable from each other, and our attention swings uninterruptedly between them. We will see also that each is indivisible in value from a shadow which lies behind it; that to the parasol of one has been added the shadow and silhouette of two figures which are more distant; that this mark in turn is attached to a dark tree-trunk in deep space; and that the tree, because of its dark foliage, has an affinity for the parasol of the dominant figure in the painting. The painting is a maze of such connecting passages, and they have allowed the artist to reduce the otherwise unmanageable detail of his subject to a color mosaic which is coherent and unobtrusive. It has often been said that an artist creates a work of art in order to discover how it should look. Seurat's performance is a reminder, then, that a color plan is not a guarantee of aesthetic bliss but merely a promise of final effectiveness, and that after this effectiveness has been discovered by the artist it must be discovered by his audience as well.

Structure and Meaning

Structure as Substance or as Skill It would be a mistake to conclude our long discussion of *La Grande Jatte* without noting that the event which Seurat has reported so masterfully might have occurred there, just as he described it. From preliminary sketches which have been preserved, we know that he made preparatory studies of the place and of the principal figures, and that he synthesized them eventually in this painting. But whether this event was intently observed or wholly contrived, it is not difficult to believe that any artist who sought to dramatize Seurat's theme, or a similar one, would necessarily produce a work having the same structural

characteristics. This conjecture has the ring of predestination that many artists find abhorrent. What it says, however, is simply that "meaning" in a work of art is conveyed as much by its form *as a structured object* as by its associative and narrative appeal. Structure is not composition in the traditional sense; it embodies meaning, and it is a substantive consideration in all works of art. By implication, it says that Seurat who was an artist of extraordinary insight, merely did what his idea required of him. Like his contemporaries who looked upon structuring as a subordinate but essential skill, he painted observable events and organized his paintings in the service of those events. That is, he responded to the world which he could observe, and reported these observations. Consequently, he painted events which were probable, or if they were not probable, were plausible, and painted them in such a way that his paintings could stand for the events themselves. In reacting to *La Grande Jatte,* for instance, the viewer is convinced that he, like the artist, is reacting directly to what is happening. But the concern of most twentieth-century artists has turned from this kind of direct and specific interest—from a preoccupation with *images of the visual*—to a more general and symbolic interest in *visual images.*

The Visual Image

It is conceivable, in painting and sculpture, that this massive concern for the visual image expresses an important distinction between modern art and the art which preceded it. This would account for the appeal of primitive, exotic art in our century, since such art is usually ritualistic and always symbolic. But in defense of tradition it must be said that all extraordinary works of art allude to aspects of experience which are nonvisual, and that they are to this extent symbolic. No one can say, for instance, how "serenity" looks, and so the serenity of Seurat's painting of *La Grande Jatte* must indeed be symbolized there. Nevertheless the consensus today is that a visual image is a subjective representation of experience rather than an external description of it, and that in extreme cases, as in the extemporaneous "action" paintings of Jackson Pollack, the visual image and the experience which it represents are inseparable.

We might have anticipated that the interest of artists in symbolic rather than descriptive images would generate a search for

alternate sources of vitality and meaning in the work. We might also have anticipated that this search would lead to a greater reliance on structural relations and to the conclusion that the meaning in much contemporary art resides, as if spiritually, in the tensions created by its elements and their attributes. And since the structural sense is an intuitive and emotional response to these very tensions, not an intellectual and associative response to events, this shift of emphasis from describable events (images of the visual) to more purely subjective and sensory experiences (visual images) has underscored mightily the need to see artistically. This need is incontestable, for works of art which are obscure and subjective simply will not submit to the usual kinds of association and interpretation. In the works by Benton Spruance, Victor de Vasarely, and Lamar Dodd which are presented here, the need to see artistically, and in this way to interpret the work from the inside out, is inescapably clear.

"Lazarus" In the Spruance lithograph (see Plate 7), images swing tantalizingly between the opaque and the transparent and between the tangible and the ethereal, and by implication, between the quick and the dead. Because the familiar and reassuring are not in the work, most viewers will feel that it is vague, and even disturbing. While conceding that one can allude pictorially to the living or to the dead, they will nevertheless be confounded by the artist's bold attempt to seize the momentary miracle which joins them. And just as surely, those who are unprepared to discover structural implications in the work will be unaffected by it. They will fail to discover in the vivid Spruance metaphor that life is opaque and dimensional as death is translucent, and that both can exist simultaneously in the freely defined and emergent figure of Lazarus. The dramatic inflection in this work is a shadow of some density where there is neither the illumination nor the mass to justify it, for this tells us that the structural posture of the work lies in its equations. These are uncertain tugs-of-war between the formed and the formless, and against this background the figure of Lazarus explodes. It is not at all surprising, then, that tentative equations should characterize its color.

"Alom" This oil painting by Vasarely (see Plate 5) is an undisguised and uncompromising appeal to the structural sense. It has a theme, perhaps, but no narrative, and if its purpose is to involve us optically in its illusion of undulating, organic space, it succeeds. The painting appears to be a square diaphram, fixed at its edges

111

and pulsating at its center; but it is in fact a geometrical pattern of some simplicity, modified by colors which are constant in hue but varied systematically in other dimensions. There are, surprisingly, only two such colors in the painting, yellow-red and blue. But these colors are the most contentious in the spectrum, the yellow-red insistently advancing in space and the blue receding, and they have been programmed into the painting so that when a change has been initiated it continues progressively for a time. The effect of these regulated changes is to cause the plane of the painting to recede at its center and to create a spatial pocket, there, which seems to breathe. The artist's reasons for selecting the hues yellow-red and blue are emotive and private, and we may speculate about them. But the manner in which he has adjusted and distributed them in this painting requires no speculation; and if the relationship between any two colors is the sum of their dimensional differences, we can simulate the structure of this painting by selecting any two colors which are related to each other precisely as yellow-red is related to blue and by modifying them according to the artist's formulas. We cannot, of course, reproduce the painting in this way, but we can certainly produce its twin.

"The Cosmos: Gold and Maroon"

On the other hand, it is quite impossible to reproduce the color relationships on which Lamar Dodd's oil painting depends (see Plate 8). The classic function of painting has been to stabilize visual experience and to accommodate those who say, "Stop the world, I want to get *on!*" But this painting—luminous, elusive, and responsive to its environment—is at odds with this tradition. One purpose of the painting, certainly, is to create the illusion of celestial, or physically incomprehensible space. Naturally then, it contains none of the visual clues which describe space with certainty; and just as naturally it asks questions to which there are no certain answers. Are we looking beyond the horizon? And are we looking through a rectangular opening into space where cosmic matter, once an unimaginable number of light-years away, is now at hand? The painting suggests that we are, for its central area, in contrast to others, is organic, complex, and unexpectedly "active."

The reasons for this activity are quite plain. The central area has been thinly painted over a gold-leaf base and occasionally wiped, a process which has left opaque pigment in many of its recessed lines and on some of its surfaces. Those surfaces which were not

painted continue, of course, to reflect varying amounts of incident light as well as much secondary light from nearby objects. The net effect is to cause the entire area to change in color constantly, either because its source of illumination has moved, because objects near it have moved, or as is most often the case, because we have moved. And quite predictably, these momentary color changes energize the center of the painting. They remind us that light is the visual equivalent and symbol of cosmic energy, and that in this century, or in another, we may indeed be looking into the eye of the universe.

Internalized Response

The gist of these comments on works of art by Spruance, Vasarely, and Dodd is that the concern of art is not singularly with *what* we see, but increasingly, with *how* we see it. This means that art and its appreciation are more consciously internalized than in the past, and that as our understanding of the physical, physiological, and psychological nature of vision increases, the distinction between the world outside ourselves and our perception of it will dissolve. Our response to a particular work of art, for instance, is undeniably not in the work itself, but in us and in the chemistry of its presence, so that the manner in which we become aware of the work affects its meaning drastically. But when at last this distinction has dissolved, it will be positively clear that the appreciation of a work of art lies initially in a perceptive response to its internal nature, and that this is a response to the harmonies and stresses of its structure.

The Need to Know More

Since vision itself turns on our capacity to make color distinctions, no one doubts that the qualities of structure are always, in some degree, affected by color relationships. And so, although we know something about color, we do not know a great deal, and we need to know more. In particular, we need to know more about how we sense and perceive color, about its effect upon our voluntary and involuntary behavior when we do, and about ways in which we can use it critically and creatively. New sources of illumination and new materials have freed artists from the double tyranny of daylight and pigments, and a renewed interest in the multidimensional nature of color has infused nearly all works of art with a vibrance which was once rare. Indeed, one of the salient characteristics of contemporary painting is its preoccupation with hue distinctions and with highly saturated color. But unfortunately, as the artist learns more, and then more, about how color is produced, perceived, and reacted to, his ability to use this

knowledge to good effect decreases inversely. So if he is not to be overwhelmed by the constant flow of such information, most of it from related fields, it is clear that someone must attempt to suggest its relevance. This book is a modest effort in that direction.